AUDITION FREEDOM

THE IRREVERENT WELLNESS GUIDE FOR THEATRE PEOPLE

BY VP BOYLE

Audition Freedom
The Irreverent Wellness Guide for Theatre People

Copyright © 2008 by VP Boyle a.k.a. Vincent Paul Boyle
www.maxtheatrix.com

ALL RIGHTS RESERVED

MaxTheatrix LLC
JAF Station
PO Box 7474
New York, NY 10116-7474

ISBN 978-0-615-25044-1 (paperback)

Printed in the United States of America
Set in Helvetica Neue & Flingaling
Designed by MaxTheatrix Creative Design Services

WE'RE ALL IN THIS TOGETHER...

This book is dedicated to everyone who has sat in the audience of a dark theatre and wept at the beauty of the living, breathing stories being told right before their eyes. It is dedicated to everyone who has found the desire to pursue theatre in some way, shape, or form inevitable. Theatre is a passion which has great value in a world that does not always understand its contribution. I am in debt to those who have preceded me in this crazy journey and I honor those who follow…

CONTENTS

THE HAPPY HOUR xi
GETTING STARTED 3

PART ONE: WELCOME TO THE FUNNY FARM 7
 THE LAST SUPPER 9
 UNIVERSAL CHAOS 12
 THE TIME & MONEY GUN IS ALWAYS LOADED 14
 EVERYONE IS DOING HIS/HER BEST 16
 THE CASTING OXYMORON 18
 YOU GET TO PLAY! 21
 YOU CAN'T GET STRAIGHT A's 22
 REWIRING YOUR BRAIN 24
 ARETHA WILL TELL YOU WHAT IT'S ALL ABOUT 27
 LOOK AROUND 31
 WHO THOUGHT TO PUT PINEAPPLE ON PIZZA? 36
 COTTON CANDY VS. COD LIVER OIL 39

PART TWO: MIRROR, MIRROR ON THE WALL 43
 THE PEANUT GALLERY IN YOUR BRAIN 45
 GET OUT OR STAY TO PLAY 49
 SHOULDN'T THE WALLS BE PADDED? 54

BIG GIRLS ARE SEXY—AND SO ARE YOU! 58

SMASH THE MIRROR 60

SLICKSTER CENTRAL: STYLE OVER CONTENT 65

SIMPLE SELF TRUTHS 69

PART THREE: DOWN THE RABBIT HOLE 75

IMPOSSIBLE THINGS 76

ON THE DECK OF THE TITANIC 79

RAINY DAYS & MONDAYS 85

THANKS FOR SHARING! 89

PUPPET PSYCHOLOGY 92

SOLVE YOUR SHIT 97

THE VORTEX OF DARKNESS 101

YOUR EVIL BITCH 103

THE EYE OF THE STORM 107

AN ALCHEMIST'S TALE 109

PART FOUR: LIVE IN THE WONKY PLACE! 113

ADVANCED AUDITION TECHNIQUES...

AN INTRODUCTION TO BEING HUMAN AGAIN 115

TECHNIQUE 1: IF YOU WALK OUT THE DOOR

AND GET HIT BY A BUS 118

TECHNIQUE 2: LOVE, LOVE, LOVE YOUR MATERIAL 122

TECHNIQUE 3: BREATHE 124

TECHNIQUE 4: LIVE IN YOUR BODY — ALL OF IT 128

TECHNIQUE 5.: BE AWARE OF A 360° WORLD 130

TECHNIQUE 6: PLAY BIG 133

TECHNIQUE 7: TRUST THE STICKY STUFF 135

TECHNIQUE 8: KEEP A SECRET 136

TECHNIQUE 9: THE MOMENT YOU CAN NEVER GO BACK 138

TECHNIQUE 10: LIVE IN THE WONKY PLACE 140

PART FIVE: EXCUSE ME, YOUR LIFE IS WAITING! 143

WHOSE LIFE IS IT, ANYWAY? 145

THE ONES WHO JOURNEYED BEFORE US 151

THE MAKE-IT-HAPPEN CLUB 156

DON'T HOLD ON TOO TIGHT 159

IF YOU MEET THE BUDDHA AT THE AUDITION - KILL HIM 162

FINDING YOUR TRUTH 164

NO ONE REALLY CARES
 ABOUT YOUR HAPPY-NESS EXCEPT YOU 166

MAGIC MOUNTAIN OR THE HAUNTED MANSION? 168

LISTEN TO YOUR HEART 171

PART SIX: HAVE FUN. NO, REALLY. 173

UNCOMMON GROUND 175

SILLY PUTTY 178

KEEP POP ROCKS IN YOUR MOUTH 180

KALEIDESCOPES, DIET COKE & QUEEN'S GREATEST HITS 182

CREATING SACRED SPACE 185

YOUR NOSE PRESSED AGAINST THE GLASS 189

WHEN YOU LAY YOUR HEAD DOWN 191

CUPCAKE KARMA & SMALL CELEBRATIONS 194

UNDER YOUR BIG ASS ROCK 196

IT'S NEVER A COMPETITION 198

THE ROAD HOME 201

"The only people for me are the mad ones...the ones who are mad to live, mad to talk, mad to be saved, desirous of everything at the same time, the ones who never yawn or say a commonplace thing, but burn, burn, burn, like fabulous yellow roman candles exploding like spiders across the stars." — *Jack Kerouac*

THE HAPPY HOUR...

I have to thank my awesome editors, Rosie Colosi and Jac Huberman, who generously gave their time and efforts to teach me the value of an em-dash over many misused ellipses. To all the MaxTheatrix Alumni, who I consider my collaborators in this theatrical journey—you rock. To my favorite theatre inspirations and friends: Kurt, Steph, Carl, Deechul, Zelma and Joe—you have no idea how much I adore you. Love and light to Amy who helped me find my way back to, well, my way. For my crazy family, especially my Mom, who through thick-and-thin understands the value of laughter and garlic. Endless love to my inner posse who give me unadulterated permission to be who I am and where I am: Bubba, JJo, DJ and Robin. Some folks only dream of having soulmates like you. Lastly I am grateful for Kristen, who didn't hang out on the planet long enough to share this with me but who was and always will be my champion.

AUDITION
FREEDOM

"I saw an angel in the marble and carved until I set him free." — *Michelangelo*

GETTING STARTED

I considered starting with a gentle introduction for about two minutes. It's not my style. I've also put off writing this book for years. Many years. I kept thinking, "Who am I to think I should write this book?" Who am I not to? If you note a subtle similarity to the Marianne Williamson quote that Nelson Mandela made famous, we're on the same page. A couple hundred more to go!

I realized one day that I hold a very unique perspective in professional theatre arena after almost fifteen years of producing some very exclusive audition workshops in New York City. I have hashed topics with brilliant Broadway casting directors from every major casting office while they gave feedback to professional actors and talked about audition technique, the crazy biz and the casting process for Broadway shows. I also believe that personal wellness in an actor's audition life is a priority and is being flippantly overlooked by the barrage of training programs, workshops, books and other informational resources available to actors pursuing theatre.

Audition Freedom is not a set of rules. It's food for thought that will encourage you to approach the audition room and your life as a theatre artist with a sense of humor, joy and freedom. Yes, it's possible! No matter what you are auditioning for or at what level, this book will provide you with ideas and tools to approach the experience with humor and friendly fearlessness. If you are an actor looking for a set of rules, put this book back on the shelf. I'll bet there are four or five books nearby that will tell you "the rules." I've read all of them. Most of them are academic and stiff, leaving no room for what really goes down in professional theatre auditions. Casting is often chaotic

and random. Isn't that refreshing? Consider this insight the first step towards audition freedom!

Look around you and you will find performers who are miserable and I'm not talking about the ones with a huge Cameron Macintosh credit. They blame everything and everyone for their poor quality of life including the types of jobs they get (or don't), how much money they get (or don't) and the unfair balance of "power" in the biz from the people making the casting decisions. I think it's all crap. There. I've gotten that out of the way. I believe most of us do theatre because *we love it.*

We love telling stories that affect an audience and remind them to feel things in a living, breathing, interactive way. Theatre is not the movies. Don't get me wrong, I love the movies a lot, but nothing is as exhilarating and personal as experiencing great theatre. *You love theatre.* You can't live without it in your life. *You need it.* I know this because we've gotten this far together. Good for you—acceptance is half the battle! Here's the catch: *You have to audition to get to do it.* Auditioning is the cog in the wheel. It's the goopey blue cough syrup that tastes yucky. It's the awful Brazilian wax job that ripped off ten extra layers of skin.

Ouch!

I really don't believe that, just so you know. I love auditions. They are this weird, wonderful and wonky experience that is just part of the biz. They aren't going away. Even big fancy TV, film and Broadway stars have to audition—sometimes under the more subtle term of "work session". It is what it is and everyone knows it.

I have been teaching and coaching for a long while because the "wow factor" is so awesome! I'm totally addicted to it and I sometimes think I'm the emperor's new clothes because it all boils down to creative collaboration with really talented people. I'm just

doing what I love and having fun. I love solving the audition puzzle on both sides—teacher and actor. It's exciting. It's silly. It's playtime. The fantabulous result from my live-in-the-wonky-place-and-have-fun approach is that my coaching clients tend to start booking jobs. The best part is that most of them relay back to me that they care less about the callback/job and more about being thrilled that they are making choices they can live with when they walk out of the room. It all becomes less personal, more artistic and more rewarding. And they get measurable results. Go figure.

"Live in the wonky place!" is something I say a lot. It's my catch phrase for the place where we are a little bit unsure of where we are going, a little bit unsure of where we have been, but trust that we'll be OK for the ride. I ask actors to trust this totally present place that they can live in that is not manipulated—sort of like surfing an awesome wave of emotion, truthfulness and storytelling. When it's over, you look back and realize that wave is gone and another is on the way. It's up to you to decide whether or not you want to swim out there and ride it. The *wonky place* is also my personal navigational tool for a more Zen approach to living in the moment and taking it all in.

It's fun. It's thrilling. It's being totally present and totally authentic.

It's well worth the time to try to get there and play, if only for a brief moment! There are a thousand ways and techniques to find the wonky place. Explore them and see what you discover—in yourself and the world around you.

Now, I want to make a deal with you.

Let's play until the end of this book. After that, you can go back to whatever modus operandi you like and work from there. Consider the twenty bucks you dropped on this book a reason to investigate like a five year old and be the mastermind of your own little universe. I want you to think about some new stuff that seems more like found-under-

my-bed-flattened-out-and-really-chewy-totally-from-last-summer-neon-pink-cotton-candy. How fabulous is that! When the jury in your brain tells you how ridiculous you are to put it in your mouth, then tell it, "Thanks for sharing!" And do it anyway.

My goal in writing this book is simple, realistic and clear. I want everyone who touches this book to walk away with at least one perception shift that will enrich their audition experience and life as an artist to be more empowered, joyful and healthy. No rules. Just sweet and sticky playtime. If you decide to turn the page, I'll take that as a big old hoot-n-hollerin' YES!

PART ONE

WELCOME TO THE FUNNY FARM

"In your light I learn how to love. In your beauty, how to make poems. You dance inside my chest, where no one sees you, but sometimes I do, and that sight becomes this art."

Excerpt from The Essential Rumi, translations by Coleman Barks with John Moyne, 1995.

THE LAST SUPPER

Have you ever walked into an audition to find twelve people sitting behind a table staring at you? That's the visual for most Broadway callbacks and it can send you spiraling into the vortex of darkness, desperately wishing you'd had a quart of green apple martini for breakfast or it can give you a wonderful giggle. I'll take the opportunity to giggle any day of the week. Who are THEY?

THEY are a bunch of folks doing the best THEY can.

I'm fascinated by the idea of THEY. I hear it all the time in my audition workshops. THEY are looking for this. THEY want you to be this. THEY like this. Let me state for the record, I have been THEY in almost every capacity at the Broadway level and I can tell you right now that it's all fiction. Most of the time, THEY don't have a clue what THEY want until YOU walk into the room and show them what it is!

I promise to do my best not to use caps from this point forward. The people "behind the table" are the ones who have been assigned to create a show. Producer, director, casting director, choreographer, dramaturge, librettist, composer, lyricist, production assistant, monitor, reader—the list can go on for days. It doesn't matter if they

are Sam Mendes or the owner of your hometown pet store who happens to run the community theatre. A show has been selected, dates are in place, the artistic team (sometimes a very loose term) has been selected and now we have to find the last missing part of the puzzle. The actors.

Theatre is a living, breathing experience. It seems totally logical to me that the only way to screen candidates to be a part of that experience is to talk to them and get a sampling of what they do. Sounds much like a living, breathing job interview, right? Whether you're auditioning for a job with great pay or for pennies and a cheese sandwich, it's all the same beast. Some folks are better at it than others. I speak from the experience of having spent two full years of my life casting Broadway shows, regional productions and original workshops/readings. It was fascinating, terrifying and totally absurd in ways I'll never be able to translate into text. It's a crazy, thrilling aspect of the business and taught me so many profound lessons in respect for the people behind the table. We'd look at hundreds (often thousands) of pictures and resumes, pick as many as we could see based on the time we had and run from there. Add in some required union calls, the artistic team requests, our last minute personal favorites and we were off to the races.

I'd love to tell you there were rules. I'd love to tell you that all of it was fair and that everyone got due consideration. I'd love to tell you that we got everything right and always made the right choice. I can't. If you can find that anywhere else in your life or even our world, I'd love to know where it is. A lot of the time we were flying by the seat of our pants in unknown territory hoping for happy accidents. And these happened all the time!

Oftentimes, we would go into the casting process with someone (a huge "name") in mind, thinking it was in the bag. Then, without warning and in the midnight hour, someone who none of us knew would walk into the room being all the wonderfully unique things

that he/she naturally is—have a great time—and knock the audition out of the park. Suddenly, everyone behind the table was buzzing, whispering to each other and flipping through pictures of people who they thought were their final choice and trying to figure out how to use this wonderful surprise that just walked out the door.

Five minutes and the world had changed.

"One must still have chaos in oneself to be able to give birth to a dancing star."
— Nietzsche

UNIVERSAL CHAOS

I visit www.hubblesite.org a lot. They have downloadable pictures of amazing things that are going on in the universe that no human has ever seen until now. How lucky are we for that in this lifetime? Much of it is imperceptible to the human eye, so graphic artists and scientists assign colors that we can see to different gases, matter densities and the like so we can view some of the universal chaos going on "out there". I believe there's a divine universal order to the whole kit and caboodle, but I'll leave that to other books and to your personal sense of spirituality!

Here's a yummy idea. The truth about casting and the audition experience is that it is sometimes totally random and barely one notch above organized chaos. Great! It's a wonderful thing, really. Maybe that's the imperfect perfection in the whole shebang. If you wrap your mind around that idea and the inherent synchronicity, you will have a starting point to find freedom in the audition room. You will discover other unexpected gifts, too. Humor. Respectful irreverence. Joy. If you start to think of it as a living, breathing experience and stop resisting or trying to manipulate what you're presenting as "you" based on "what you think they want" or some set of perceived rules, you're already in a new place that will set you up to have fun. And win. Huge. Really huge.

Why?

You're being authentic. You're taking responsibility for your mental health, your personal wellness and yourself as an artist—and not

taking responsibility for everyone else in the room. You're doing what you love because you have chosen to be there and want to do it. You're making decisions for the only person on the planet you are allowed to make decisions for—yourself! That is part of our lives as artists. Everyone is creative in some way. You have chosen to learn skills that make you a masterful theatrical storyteller. Someone who can take words or music or movement that was created by someone else and breathe life into them in ways that no one else can because of your unique life experiences, your body, your brain, your age, your sex, your everything.

That is why you are *an artist.*

I don't care if you are 18 years old and reading this book before going off to the University of Michigan or 60 years old getting ready to audition for the local JCC production of *Brighton Beach Memoirs.*

You are an artist. A creative being. A person who just happens to love theatre. There are more people like you out there! Meet them, collaborate with them and join forces to tell great theatrical stories while doing what you love. You must find them. You must nurture them. You must let them nurture you.

One of them happens to have written this book!

"Guard well your spare moments. They are like uncut diamonds. Discard them and their value will never be known. Improve them and they will become the brightest gems in a useful life."
— Ralph Waldo Emerson

THE TIME & MONEY GUN IS ALWAYS LOADED

Boy, it always seems to come down to time and money, huh? Certainly that was what my lower middle class, Midwest belief system was based upon through most of my twenties. Not much room in there for artistry as I see it, so I changed my belief system. I'm always changing it. I'm continually working on my own paradigm to integrate renewal and presentness into my work in theatre. Money is good. We need it to survive. It is definitely something that needs to be acknowledged and handled. More personal free time is always better because we can relax and appreciate the time we have! Learn how to respect the time/money equation in theatre sooner rather than later. Then you can approach the audition with honor, respect and artistic integrity.

Why is that so important?

Everyone is stressed, anxious or fatigued and it starts behind the table. In the ideal world (an oxymoron), the creative team would have no budget limitations, all the time in the world and infinite choices with which to create a theatrical experience. I hesitate to use the word "show" or "play" since the current commercial theatre genre is vast and those terms are often associated with things that are far from well-crafted dramatic stories, but are more often thrilling "theatrical experiences." So be it—I love it all.

AUDITION FREEDOM

I sometimes think we should call the performing arts "Theatre Sports" so we can acquire the status that athletes have in our society and the budget to go with it. Theatre folks are up against it all the time for funding, commercial viability and sustainability no matter what the level. You will find 100 or 1000 times the attendance to any sports event than you ever will find at a theatrical event—and everyone involved will have more money. The players, the promoters, the coaches, the fans. I could have easily said the actors, the producers, the artistic staff and the audience. The collaboration prior to the event is much the same. It is what is! Don't get angry about it.

Understand how it affects everything down to this crazy thing called *the audition.* Have compassion and respect for the people behind the table because they are under as much, if not more, pressure as you are when you walk into the room. They want you to be the answer to their prayers. It's true! The faster they can locate the perfect person for what they need, the faster they can move on to other things. Not bigger or better things, just more pieces of the huge puzzle that has to be solved before opening night. Give them a huge break before you walk into the room. Start with being thankful that you get to do something you love to do.

"Assumption is the mother of screw up."
— Angelo Donghia

EVERYONE IS DOING HIS/HER BEST

We're all human. I struggle with seasonal allergies. I'm allergic to everything. Literally. Dogs, cats, pollen, my mother. It's part of my unique entity. I remember working on the casting of the national tour of *Cinderella* and we were required by the union to have another Equity Chorus Call for the show[1] (which was already cast) so it was going to be a full day seeing almost three hundred young soprano girls sing 16 bars of standard ballads when we didn't have anything left to cast in the show. Imagine hearing girls scream high C's all day long...

Even on a good day, this is a challenge to navigate, let alone through a downpour of green goop in my throat and a virtual ice pick sticking in my eyeball. We had so much going on in the casting office, that no one could cover me on the audition. "Calling out" was not an option. We were spread out all over the city holding auditions for different shows in various studios. I had to do it. By the time I got to the studio, I was ready to curl up on the studio floor and take a nap from the double dose of anti-histamines I took and the impending migraine was starting to cause white spots in my vision. I'm particularly fun, outgoing and friendly when I conduct auditions whether I'm casting, directing or producing. Having been on all sides of the fence, it's important to me. That being said, I was trying to figure out how on earth I was going to make it through eight hours of ingénues and get home to my bed and an ice pack. I pulled up my bootstraps and hoped for a miracle.

1 There are tons of books out there that deal with all the information regarding unions, professional auditions and the like so I'm not going to spend time elaborating on them. They make me a little sleepy, but I read them anyway for research. You should, too.

AUDITION FREEDOM

The day progressed and I was doing my best while trying to be still and somewhat quiet as I personally battled the pain in my head. When I was walking through the waiting room on the lunch break, a young actress that I knew (and adored) came up to me and started apologizing profusely for how poorly she had auditioned. I was in shock. She was fabulous as always and had knocked it out of the park with solid preparation and great choices. I asked her why she thought she had done poorly and she replied, "Well, you're always so upbeat and enthusiastic and today you seemed so quiet, I thought you were mad at me." Mad? Are you kidding?

That was the farthest thing from the truth. It was total fiction in her head! I told her I was battling a migraine headache and just couldn't be at my usual high level of energy. We laughed about it (gently, of course) and we both agreed it was such a great lesson in not guessing at what the people behind the table might be thinking. It's impossible! And totally unfair.

Doesn't everyone have a rough day at work, sometimes? Some days are more productive than others. Some flow easily, some we blame on Mercury being in retrograde. Some days just suck because our boyfriend/girlfriend broke up with us last night, we had to euthanize our dog because of cancer, or because two planes just crashed into the World Trade Center and our world is a mess while Air Force jets circle Manhattan all day and all night.

We're human. We do the best we can. That includes you as an artist and everyone else involved in the audition experience. There are going to be days when it goes smoothly and days when it feels like pulling teeth. The bottom line is that in the end, only you can choose how to perceive the experience and integrate it into your life as an artist.

Wow, that's huge. Reread that last paragraph a few more times to drill it into your brain.

"Quit now, you will never make it. If you disregard this advice, you will be halfway there." — David Zucker

THE CASTING OXYMORON

Are you ready for another wonderful step towards audition enlightenment? You can suck and book the job.

It's true. You can be total-sucky-sucky and still end up with a contract in your hand. It's not the Karma Police serving it up hard to some folks and looking the other way for others. It's life in theatre. Sometimes we (the creative team) ignore the actual audition and make our choices based on hundreds of other reasons that have nothing to do with logic or the audition we have just witnessed.

Here are ten examples:

1. You're someone we have worked with before and we already know what you can do.

2. We are totally sexually attracted to you and want to see you naked in our show.

3. You're an extreme type in some way (super tall, super weird, super funny, super skinny, super old) and we need you.

4. You're the producer's girlfriend and half of the funding is based on an off-the-record verbal agreement to cast you.

5. You're nice and the other casting option has an attitude problem or history of being totally high maintenance and crazy.

6. You're an ethnic minority.

7. You're a soap star that will sell tickets.

8. You fit the costumes.

9. You'll work for scale.

10. We've run out of time and options we have to just choose someone. Anyone.

Get the picture? More often than not, solid audition technique, diverse skill sets, type and artistic integrity are the key factors in getting the callback or the job, but not always. You may be thinking that the whole thing is hopeless. Far from it.

I see accepting this truth as a huge opportunity to let all of that stuff go and just *do your work*. When you really grasp the bigger picture, your happiness becomes your choice. If you decide to walk into the audition room and tell a personal story with words, music or dance, it is *your choice*. If you accept yourself as an artist, it is *your choice*. If you are able to walk out of the room feeling great about your work and who you are, it is *your choice*. If you want to be a star, do what you need to do to be a star. It may or may not have to do with artistic integrity. It may or may not give you happiness. If it gives you a mansion, a Hummer and a private table at NOBU, great! Invite me to dinner and let me start a scholarship fund in your name.

You might ask yourself, "If so much of the casting process is not about actual talent, what are my chances of making a living or getting cast every once and a while out of pure luck?"

Here's what I absolutely know to be true—not much! I do know that if you do the work, learn to enjoy the process as part of the life you want to create and take committed action towards your theatrical artistry, things will happen. It may not be tomorrow or at the same speed

folks around you are seeing "activity," but the results are inevitable and it will add up to a rewarding journey. This is the only truth I'll tell you that I really believe based on measurable, tangible results. And yes, talent matters a lot. Talent is the starting point for everything in the casting circumstance and in the collaborative creative process for theatre. However, having talent doesn't dictate wellness, happiness, joy, humor or personal fulfillment.

I'm right here with you in the yummy mess of it all doing the same thing! Better yet, I'm having a life. I'm having fun. I'm accepting my never-ending journey as a creative spirit and an artist. You can, too.

"Have no fear of perfection, you will never reach it." — Salvador Dali

YOU GET TO PLAY!

In my workshops, I always work from many different angles. I work on all of the experiential technical stuff while working with actors one-on-one. Breathing, text, focus, physicality, specific storytelling—easy fixes that deal with craft. I am also always asking questions to help folks wrap their minds around a healthy psyche about auditioning. That is why I'm writing this book and not another book about "rules". I teach many perspectives and techniques when it comes to the acting work, but I only work one way with regards to our psychological approach to the audition.

You always get to choose.

Why not have a little fun? Hell, why not have a lot of fun? No one is responsible for your happiness except you. No one is responsible for how you feel when you walk out the door except you. No one is responsible for your life as an artist except you. Auditions are a "get to" not a "have to" in my book. I've stolen that idea from ten different sources and have no qualms about admitting it. I love auditions on either side of the table because it's another chance to do what I love—theatre. I get to do it! If you don't love it, love it, love it then get out. Do something else. Life is way too short to be spending time on anything you don't enjoy. It's really that simple.

"Walk in the rain, smell flowers, stop along the way...build sandcastles, go on field trips, find out how things work, tell stories, say the magic words, trust the universe." — Bruce Williamson

YOU CAN'T GET STRAIGHT A's

In elementary school and high school, I was a straight A student. I was in every club and barely slept. I never watched TV. Ever. Even to this day, I don't have the patience for it and have given up trying to learn it. Now I rent television series that I hear are great on DVD and watch an entire season in one fell swoop. Over-achiever? Almost to the point of disease. The truth is that it took me many, many years to appreciate the journey of learning to love *the actual learning part*. I was always doing, doing, doing just to get some trophy or piece of paper that said I was good or that I had achieved something. I wanted kudos. I wanted every goal on my list to have a check mark next to it. I wanted it yesterday. Not tomorrow. Not next year. Not in my own time. I didn't care about process or the experience of trying new things. I just wanted to be good. Not good. Better. Better than everyone else. I was always fixated on the result and trying to be lauded with some ceremonial stamp of approval that indicated success. Sound familiar?

I cared more about a little piece of paper that had a column of A's and 1's than I did about what I was learning to achieve that piece of paper. The fragmenting of this approach really started to hit home in college when I didn't have the time to do everything and had to choose. Even then I battled the inner voice wanting to be a actor and got a Bachelor of Science degree in Marketing! All the while I insisted that I was taking acting, voice and dance lessons "just for fun." Nonetheless, I spent every single summer doing community theatre,

summer stock or theme parks. My best friends laugh at me now because they said they never even questioned that my life would be about theatre! Theatre doesn't have a report card. It's collaboration, inner artistry and process. Soooooooooo much process!

That was a huge perception shift that took me many years to really understand. "Getting the job" was not a direct response to my doing great work. I could be brilliant, prepared and do all the right things and not get called back. Come on! Isn't that the reward? Getting to your dream? Getting that show? That role? That contract? That paycheck? Nope. It's not. We've already hashed out all the craziness that plays into that equation. There are no straight A's or perfect report cards for artists. You have to enjoy the work. That is the nuts and bolts of it.

Our capitalistic, yanged-out culture doesn't cherish the journey. It is centered around tangible, materialistic "things" or end results—which is ironic since the idea of beginnings and endings is a paradox. No-Thing will make you an artist. No-Thing will make you fulfilled. Our creative life is why we're here and you may have to mentally burn (many times) the idea of a straight A report card and personal wish list of fancy toys.

If you have a little voice in your head yelling at you incessantly, you'll never find freedom in your artistic life let alone in the audition room.

"You have to get straight A's to prove you're smart."
 "You have to be nice all the time to prove you're likable."
"You have to get the lead role to prove you're the most talented."
"You have to buy expensive things to prove you're successful."
"If you're not working by now, you're never going to make it."
"You have to be on Broadway to have made it."

Blah. Blah. Blah. Blah. Blah. How can we stop the self-defeating chatter?

"We have to learn to be our own best friends because we fall too easily into the trap of being our worst enemies."
— *Roderick Thorp*

REWIRING YOUR BRAIN

From this point forward, we are going to actively engage the chatterbox in your brain and challenge your perceptions about auditioning and your life as an artist using one minute brain exercises called *Audition Mind Tools.* Think of them as a moment to percolate on some notion of the audition experience or your artistic expression. They run the gamut from silly to sage. Since I'm assuming you agreed to play with me for the course of this book, I'll assume that asking you to stop reading and do a mindful exercise, game, visualization or rumination that will require less than sixty seconds of your full concentration is also acceptable. If we stack the deck in your favor (I always do), you will find more than one thing in these pages that triggers some subtle shift in your work and/or life as the actor/artist you have chosen to be and you can write off the lifetime ripple effect as icing on the cake.

I'm always throwing out random thoughts to my students about how to look at their auditions. Some thoughts are crazy and totally off-the-cuff. Some are simple suggestions or subtle language substitutions to create shifts away from negative ideas about auditioning and one's self-esteem. Some are totally my own personal blasphemes that I enjoy. In the end, I leave it up to you to decide if you agree, disagree or choose to seek more information. Only you can decide for yourself what feedback is valid and worthy of consideration. When the constant opportunities for feedback and new information come your way, *don't panic.* Trust your gut and know that you can listen, learn, experiment and ultimately make the right choice to serve your life as an artist *at this time.* Nothing has to be forever and remember

that for every decision you make, you can change your mind later. When it comes to feedback, opinion or otherwise, always reply with authentic gratitude to yourself and those around you. How? Just say, "Thanks for sharing!"

AUDITION MIND TOOL: THE VANILLA ICE CREAM DECISION

Think about vanilla ice cream. It's always a pretty nice thought in my head.

You have just rented the entire *Lord of the Rings* trilogy and decided that you want—and desperately need—vanilla ice cream before Frodo's journey begins so you put on your shoes, throw on a coat and haul yourself to the grocery store in the rain to get what you need. When you arrive at the frozen section, you find twenty different possibilities behind that chilly pane of glass that would all qualify as great vanilla ice cream. Some are on sale. Some are ones you've tried before, but most of them you haven't. Some have really cool packaging! Some are low fat while some have artificial ingredients. You find yourself drawn to those that have natural vanilla bean specks in them (my personal favorite). Some call themselves "custard", "gelato", "sorbet", "yogurt" and more, but for your purpose they could all serve as the Holy Grail of "vanilla ice cream" right about now. Guess what? You're only going to choose one.

You consider them all and then when all those possibilities are swimming around in your consciousness and your virtual mouth, you will collapse the possibilities into one choice, here and now and file the rest of the information away for future reference because you are tired of drinking your own saliva as you stare at the creamy goodness that awaits you. It doesn't mean you didn't like all of your options.

Welcome to the casting circumstance!

There's no fault or blame to the process. We have to pick one type of vanilla ice cream for that monster banana split we are making called a show—play, musical or otherwise. Everyone is going to have an opinion and someone is going to make a choice. Just like you do as an actor and artist. You might be the flavor of the day. You might have to wait a little bit. You might find you aren't willing to wait and find different opportunities to pursue. Who knows?

You do. You know if you feel confident in the choices you are making and have made and if you have prepared properly. You know if you had fun along the way and are committed to today's possibility to do what you love. You know if when you walk out of the room, you feel talented. You and only you know—so listen to your soul once in a while and chill out about the entire audition process.

*"Respect for ourselves guides our morals;
respect for others guides our manners."*
— Laurence Sterne

ARETHA FRANKLIN WILL TELL YOU WHAT IT'S ALL ABOUT

R-E-S-P-E-C-T! Respect for the art. Respect for the process. Respect for all the people involved in the audition experience. Respect for *yourself*. How many times have you been waiting to audition for something and someone is bitching incessantly about the people in the room, the long wait, the people who have been pre-cast, etc. The vomitous spew can go on forever. I politely urge you to run as fast as you can to get away from all that stuff. It will kill you. It's a deadly virus which will infect your work, your self-esteem, your artistry and any hopes you have of finding some joy and balance in the casting circumstance.

I'm not saying it's easy. I have been sucked into the viper's den on many occasions only to walk away and beat myself up for participating in that negative nonsense. I've put considerable thought into how to solve this aspect of the audition and I think more often than not, it's not a bunch of malicious actors but rather a bunch of *insecure* actors who are trying to deal with a not-so-perfect situation by putting their energy into the wrong space. Here's one of the first places you can really create a huge shift towards confident artistry: *Don't play that petty game.*

It's toxic. It won't serve you. And it will slowly disintegrate the fabulously positive things you will bring into the audition that make you one of the people that everyone wants to work with—qualities like humor, effervescence, empowerment, authenticity and respect. I'm not

being righteous or a total Pollyanna about the audition circumstance. I know that sometimes it goes better than others, but so are all the days of our lives. It's the gentle little shifts and commitment to trying to do better that make this ever-lasting-gobstopper of a journey a colorful one of growth and learning.

The customer service aspect of people who work in fast food joints intrigues me. Having come from the Midwest, my standard for courteousness and work ethic is pretty high. That being said, I used to get really mad about the attitude and lack of friendliness in NYC. I'm talking really mad. Road rage without the car. Yes, I know it's not just in the Big Apple, but there are some days I could use a friendly smile much more than a careless grunt. If I told you it still didn't bring up my personal "stuff," I'd be lying. However, I started to really look at how endlessly hard their job was and how personally unfulfilled it must seem doing it day in and day out. While one can debate that there might be some creative artistry somewhere in that equation, it would certainly be an uphill climb.

It makes me feel like one of the luckiest people in the world that I can do all the theatrical things I do when I get the opportunity to do them. Out of my respect for my craft and my commitment to theatre, I decided to acknowledge myself and the delicious fact that I'm choosing to be there. No one forced you to buy this book, did they? No one demands that you subject yourself to the casting circumstance. No one except you and that little beast inside that is screaming, "I am an artist! I love this stuff! Bring it all on! I can do this! I love to play! I love telling stories! More! More! More!"

Look at the world around you and you'll realize that many others do not see the possibility of fun and creativity in their "jobs" or even their lives. Theatre may not always be a consistent paycheck or have as many zeros as we would like at the end of the ones that we do deposit into our bank account sometimes, but we are the fortunate ones who get to do theatre. Very fortunate, indeed.

Have you ever thought about the fundamental aspects of respect? Respect, for our purposes, is defined as a "high or special regard" to something or someone. Whether you have familial respect for your elders (parents or grandparents) or an artistic respect for Meryl Streep and her work, any example you ruminate on and define is founded in your experience of them and their creative contribution to life. It's your life, right? Respect yourself and your craft. Isn't a "bad audition" any day of the week better than doing some number crunching job for someone else's bottom line? You might even call this respect for your commitment to theatre a reason to be a better you than you ever dreamed possible. Here's a ten dollar question…

Who respects and admires you?

At this point in your life, where have you historically set examples that allow others to be inspired by you and show you respect? You may have had many or you may feel a sudden wave of heat across your face from the fear of trying to wrap your mind around this idea—it's all good!

How well do you choose to shine when it comes to pure respect for yourself, your artist commitment and your integrity?

AUDITION MIND TOOL:
POLISH YOUR SHOES UNTIL THEY SHINE

Look at everyone's shoes in your vicinity—on the subway, in your class, at the grocery store, wherever. If you are home alone while you are reading this, go look at your closet and all the shoes in it. Look at your roommate's shoes. Your lover's shoes. Any closet that might be fair game and not get you killed for snooping around in it. If you are an overachiever, remember to look at everyone's shoes at your next audition. Just notice things. No good or bad judgment calls. Just notice the relationship between shoes, people and the

conclusions you draw from them. Remember—don't take more than sixty seconds!

Which pairs resonate with proper care and respect for the feet that inhabit them? It's comical how many Broadway level casting directors obsess about shoes. I have to admit that I do it, too. Anyone who spends considerable time auditioning actors will develop a shoe fetish very quickly. I believe part of this sick little tangent comes from the visual perspective of seeing people walk into a room and stand approximately 10-15 feet from you to perform their song or monologue. You naturally scan from head to toe and linger at the bottom of the visual to decide if you like what you see. I don't care so much about the types of shoes I see but it drives me bonkers when I see folks in scuffed up sneakers and unpolished dress shoes that barely have soles on them. I get personally offended that they couldn't take the time to respect how much effort and money was being spent to see them. Add a wrinkled or unkempt shirt and I'm more than irritated. Everyone can afford one nice pair of shoes. If not, you can get a free pair from The Actors' Fund.[2]

Next time you are getting dressed for an audition and putting on your shoes, start from the ground up and create some gentle awareness and kindness towards the person that inhabits them. Shower yourself with ceremonial praise and respect from your shoes all the way up to your brain. Be kind. Be nurturing. Grant yourself some peace in being grounded to artistry in theatre.

And if they aren't in spectacular shape, please polish your shoes or buy a new pair for your next audition. It's a ceremony that demonstrates respect to all the parties involved in the audition—and you'll feel great!

2 In 1945, actor Conrad Cantzen bequeathed his estate to The Actors' Fund with the stipulation that it should be used to help actors purchase shoes so they did not appear "down at the heels" when auditioning. Mr. Cantzen believed that a good pair of shoes made a great first impression on casting directors. For more information, visit: www.theactorsfund. org.

"There is a vitality, a life force, an energy, a quickening, that is translated through you into action, and because there is only one of you in all time, this expression is unique. And if you block it, it will never exist through any other medium and it will be lost." — Martha Graham

LOOK AROUND

Being present is tough. Really tough! You know why? We as humans don't really appreciate or process the full range of information that we can absorb as these wonderful sensory beings. We *love* the "good" stuff. I use that term half jokingly, because it's so misleading. We get somewhat addicted to things we have learned to need. Whether that's sugar, self-deprecation, fear of success, cocaine, diamonds, tattoos, whatever. This list can go on for days and somewhere along the line you'll find a shoe that fits. The crash that comes from all of this "me, me, me" stuff is that we really forget many things that make us instruments of total consciousness.

We forget to listen. To acknowledge. To accept. To respect. To receive. To release. To play.

Those are some personal favorites that I'm always working on! What does that have to do with the casting circumstance, you may wonder. Theatrical experiences are interactive and involve that extra participant that we learn to love when we are on stage—the audience. We invite them into our story. They are part of the living, breathing fabric of the journey. There is no story to tell without the audience and we grant them great respect in the course of our experience with them.

Why not the folks behind the table?

It's a miraculous feat that actors can rush into a room to rip open their heart and soul with such great passion, and then flee the room without really taking in anything—including the human beings who are there to share the experience. It happens all the time. I have coached Broadway professionals for huge callbacks and then asked them who was in the room after the audition only to find out that they have no idea. I'll get such wonderful specifics like "an old guy in a sweater" or "I think it was the director."

"You think?" Holy cow.

My questions continue: "Did you say hello?" "What did they ask for?" "Did they give you adjustments?" The humor of the situation is that sometimes all the actor can remember is a blur of their own performance.

Stop and look around!

You have to be able to walk into a room and really be present for the experience. If you struggle with this in any way, make it a priority to figure out how to really see and listen. It's tremendously important. One of my favorite casting directors in New York gives sage advice in my workshop—pick one goal to accomplish at every audition. I take it a bit further to say keep it simple and accomplish it *three times in row* before moving on to something else.

Some suggestions that are simple and add up to fantastic audition technique over time:

1. Make eye contact with the director.

2. Repeat in your mind any questions that are asked of you before answering.

3. Take an extra breath before starting your material.

4. Live in your closing beat (song or monologue) a second longer than you want to.

5. Say "Thank You" when you're done and really mean it.

6. Wish the artistic team good luck in their casting.

7. Pick one "rule" you have always followed and break it.

8. Give yourself permission to "look stupid" and be totally, fabulously human.

Get the drift?

If you can find it in yourself to methodically test out new ways of being in the audition and to create a strategic checklist of goals to conquer in the journey, your technique will improve light years and you'll see something unusual and quirky happen—you'll have fun. You'll become someone who walks into the room, shares their wonderfulness and is willing to play. Rather than pushing a "persona" or "type" or "set of rules" at us, you'll be asking questions that indicate you're an artist.

I'm going to give you one of my favorite sayings that I think generates success for actors, both internally and externally.

"Let's try it!"

Memorize it. Believe it. Own it. Use it often. Whenever you are asked to try something (no matter how loudly every molecule in your body is screaming to your brain that the suggestion is totally ridiculous and will never ever work), simply respond with: "Let's try it!"

You know why I love that saying so much? It indicates willingness, openness, courage, confidence, exploration and most importantly— teamwork. Notice I didn't say, "I'll try it." It's all about the idea of you and me working together. It's about "let us" not "let me." Brew on

that and integrate it into your artistic life as soon as you can. You'll find it adds to the idea of presentness because suddenly there is true collaboration.

Give and take. Action and reaction. Offer and accept. Sounds like acting class, huh? I just threw out some of the most used jargon in acting. I call them "puke words" because so often they are used without a real sense of the craft that lurks behind them. They've become pop slang that has lost meaning through years of actor abuse.

So the question becomes how do you stay present in the audition if the director, Mr. Crusty Kranky, doesn't share your sense of adventure and newfound *joie di vive* in audition-land? You look for treasure. You solve the puzzle. You play the amazing race. You sniff for clues.

AUDITION MIND TOOL: THROW ME A STICK

I think dogs really get it. They have their priorities straight and live totally in the moment. Life is an awesome combination of eating, sleeping, playing, pooping and hanging out with people who love you. Throw in some snow, an old shoe to chew, a good stick to fetch, some crotch sniffing and the world is their oyster. Sign me up for that life in the next round—I'm a Great Dane at heart.

Auditions are full of thrilling unknowns. You gotta love it because it's a big, silly game. It can be fun. A puzzle to solve. A yummy stick to catch.

Why do people turn into puddles of mush when they see any puppy on the planet? I mean, really think about it. You just can't look at a puppy without being reduced to some adolescent blob of grinning goofiness. No matter how serious you are, it's a delight because this

creature with absolutely no coordination in front of you just wants to play, play, play with everyone who is willing. Think about that! You only have to remember three words.

Bring. It. On.

"Bring it on!" is a great cue to imprint a sense of playful courage in your brain. I'd take it one step further (I always do) and make it a code word. Pick something delicious and irreverent. Something secret that you never share so that you keep some mysterious sparkle in your eyes.

Something like—WOOF.

That's hot. Woof. The Zen nature of dog life and fabulous freedom to "bring it on" in auditions just for the fun of it all wrapped up in a code word like WOOF. Divinely inspired, if I do say so myself. Like you, I'm an artist!

What will your word be? I want you to write it somewhere so that you will see it the next time you audition right before you walk into the room—whether it's in your journal, by your music, or on the back of your hand.

Simplify the situation (with your code word) to nothing more than the idea of good ol' tail wagging dog play and see what surprising things happen.

*"I never came upon any of my discoveries
through the process of rational thinking."*
— Albert Einstein

WHO THOUGHT TO PUT PINEAPPLE ON PIZZA?

We forget that everyone involved is actually human.

There is no perfection in the mix! Utopia is impossible and it makes for lack lustre theatre. When we go see a play or musical, we want genuinely flawed characters and juicy stories. We want universal themes about love, dreams and fantasies that we yearn for and empathize with and pay $120.00 for an orchestra seat with limited view. We aren't really interested in perfect people. We want ones that aren't navigating some conflict and working out their struggle in front of us for our entertainment. We are interested in that very odd beast: human behavior.

A big, fancy, Tony Award winning director is still human. It's true! He or she is still trying to find the next job, manage their mortgage or rent payments, beg their spouse to put their socks in the hamper, get their cavities filled, take fish oil capsules because of an annoying eczema patch behind their knee, read the latest Harry Potter book, pick up their dry cleaning, lose ten pounds and all the other little things we do every day. No one is immune to all the details of life that present themselves every second of every minute of every hour of every day of every year until we die. We are all equal. We are all human. We all want things to go the way we dream them, easily and efficiently. Sometimes we are just not someone's cup of tea. And it's not personal! It's really not.

I'm human. I hate ham and pineapple on pizza. It all looks and tastes really wrong to me. One of my best friends loves that crazy combo. So

be it—I'll stick to classic pepperoni and cheese. Call me old fashioned or stuck in my ways, I just don't think that half of a Pina Colada and some breakfast bacon should be on my slice. We still share a common love of some crusty goodness and each other's company without a second thought to the other person's preferences.

Nothing about it is personal—it's just pizza. Everyone on both sides has different things to offer and to choose. There are always two sides to the casting equation. The creative team has choices to make *and so do you.* Why can't you pick and choose what projects you want to audition for and which ones you do not?

Why can't you have a discussion with your agent about what kind of money you are willing to work for and when you feel you should pass? If the choices are handled intelligently, responsibly and with respect, you will find yourself more focused on your creative choices and how they integrate into a balanced life instead of just trying to "get every job." The people around you will either understand or not, but it's not their responsibility to make the final choice for you. Get information, do research, ask a mentor, seek spiritual guidance—whatever you need— then decide for yourself what is right. Where is the rule book that says that you have to take every job or audition for every show? If you don't want to do something, don't do it. Plain and simple—don't do it. No matter how big the role, how much it pays, who is directing— you can just fill in your personal string of actor chatter right here. We all have some. Yes, there may be an opportunity cost[3] to the choice, but it's investments in the experience portfolio of your life and you have the final say on what you'll buy, keep and sell. Exercise it! Savor the choices you navigate to become part of your life experience. They are yours and yours alone to make.

How do you know if you are doing the right thing?

3 In economics, the opportunity cost of a decision is based on what must be given up as a result of the decision. Any decision that involves a choice between two or more options has an opportunity cost.

Trust your gut. Make a decision and see how you feel. Quiet your brain and listen to your body instead. Do you feel calm? Centered? At peace? Really check in once in a while instead of barreling through everything at lightning speed and ignoring the quiet, little voice inside your heart. If you still struggle with uncertainty about your choices, ask yourself before you go to sleep at night if it was a good day to be alive and if you are happy with all the things you did. No matter what answer bubbles up from the inner depths, rest easy. You're human.

Tomorrow is a new day to create again.

*"To live is so startling it leaves little time
for anything else." — Emily Dickinson*

COTTON CANDY VS. COD LIVER OIL

Which is better? Neither, really. Although I'm a sugar junkie at heart and would much rather have cotton candy for breakfast, there is a valid argument that both options are simply just two different "tastes" to stimulate our senses. Two possible tongue adventures that are available to us for the choosing.

You know where you can create the biggest, most profound shift in your audition experiences? Truly experience them. Feel them. Taste them. Smell them. Breathe them in like they will be your last. If they make you want to vomit, then vomit and go brush your teeth. If they give you dry mouth, lick your lips and buy some bottled water. If you love getting up on the morning of a juicy audition, then make it festive and pretend it's your own personal holiday.

It sounds so simple, but 95% of the actors I work with barrel through every opportunity they have to perform or tell their stories through text. Isn't that why we chose this career — to speak from our soul and find interesting stories to experience, imagine and create?

Wait a minute, isn't that life itself?

I challenge you to feel every emotion, breath, step, word, note, heart palpitation. All of the experiences (including auditions) that we create are part of the fabric that is our aggregate artistic expression. Don't avoid it or become addicted to the notion of a "good audition" versus a "bad audition." They are all a part of this expression and the sooner that you realize there is no perfection in the deal, you'll start living in the moment a heck of a lot more.

AUDITION MIND TOOL: THE TAO STORY OF TIGERS ABOVE, TIGERS BELOW

There are many versions of this story, but I share this version with you. Percolate on it with the idea of really tasting, enjoying and experiencing every aspect of your audition life. Mark this page and revisit it more than once. I guarantee that it will deepen its meaning to you over time...

A man was walking across a field when he heard a rustling in the tall grass beside him and turned to see the hungry eyes of a large tiger staring at him. The man began to run, fear giving him greater speed and stamina than he knew he possessed. But always, just behind him, he could hear the easy breathing of the hungry tiger. Finally, the man stopped, not because his strength had failed but because he had come to the edge of a high cliff and could go no further. "I can let the tiger eat me, or take my life in my own hands and jump." The man turned and saw the tiger slowly walking toward him, licking its mouth in anticipation. Resolved to take his own life, the man stepped to the edge of the cliff and bent his legs to jump, when he suddenly noticed a thick vine growing out of the side of the cliff, several feet from the top.

Carefully, he let himself drop down the face of the cliff, catching hold of the vine as he slid past and thanked God when it was strong enough to support his weight. Hanging now, the man looked up and saw the tiger's eyes peering over the edge of the cliff. It roared down at him, then began to pace back and forth along the top of the cliff. For the first time, the man looked at the vine that had saved his life. It was thick enough for him to wrap his legs around, resting his arms and long enough that he might be able to let himself far enough down to jump safely to the ground below. And the moment he had this

thought was the same moment that he saw a second tiger, pacing back and forth at the foot of the cliff, licking its mouth and looking hungrily up at him.

Well, thought the man, "If my strength and the strength of the vine are great enough, perhaps I can out wait the tigers. Surely, they'll go someplace else to eat when they're hungry enough." The man prepared to settle in for a long wait. His preparations halted quickly, however, when he heard a scurrying, scratching sound close to his own face. Glancing upwards, he saw two mice, one white and one black, emerge from a small hole in the cliff. They made their way swiftly to the base of the vine and began to gnaw through it with their small sharp teeth. There was nothing else he could do, a tiger above, a tiger below and the vine that kept him from their jaws about to break.

The man was closing his eyes to begin his final prayers, when he noticed, a little to his right, a tiny patch of red color on the face of the cliff. He reached toward it precariously, pulled and brought his hand back beneath his eyes.

There, in his palm, was a luscious, red strawberry.

The man swiftly pressed the strawberry between his lips, onto his tongue and hanging between those still visible tigers, *he enjoyed the finest, juiciest, sweetest meal of his life.*

Great story, huh?

Every time I revisit it, I find something new to ruminate on — I encourage you to apply it to your audition life and do the same.

VP BOYLE

PART TWO

MIRROR, MIRROR, ON THE WALL

VP BOYLE

"A critic is someone who never actually goes to the battle, yet who afterwards comes out shooting the wounded."
— *Tyne Daly*

THE PEANUT GALLERY IN YOUR BRAIN

Who are you? Who do you see when you look into the mirror every morning with toothpaste foaming down your chin?

If you buy into the idea that our words and thoughts have great power and that on some quantum level they create virtual reality, then the idea that we have to choose our words and thoughts in alignment with what we want to become and create becomes a tangible reality. There are gobs of books on why our perception of reality is all fiction, but the best and easiest way to understand this is watch *The Matrix* and do a little research on quantum physics.[4]

I'm obsessed with using the word "artist" instead of "actor" and how we can infuse it with depth, color, texture, energy and life force. The word "artist" feels to me to be much more empowering (and much less limiting) than "actor." Our society has some very interesting assumptions about actors: dumb, superficial, poor, misguided, selfish, ignorant, etc. The twisted irony is that when our world is falling apart or the human race is in the darkest of days, it is the artists (past and present) that bring much of the healing light to our world.

I'm not talking about celebrities!

4 There is a great film called *What The Bleep Do We Know Anyway?* that is an interesting and easy introduction to many ideas centering around quantum theory and how we can affect reality with our intentions and thoughts. If you're particularly interested, the book version is much more in-depth and draws upon many informative (yet entertaining) sources including scientists and spiritual masters trying to integrate their points of view in light of recent scientific discoveries.

Celebrity is a whole different idea that has become part of the Western value philosophy of success based on media, wealth and power. Financial responsibility, prosperity and contribution have nothing to do with "bling." Gosh, I really despise that word and all that it connotes in our society's subliminal idea of success! It really screws up artistry on so many levels. Yuck.

When you use juicy words of desire that summarize your goals and your dreams, what are they? Does it bring up warmth and the idea of prosperity? What about peace and a strong sense of spirituality? Do you gravitate towards thoughts and language that are effervescent and make you feel healthy?

If you're not easily responding with a "Yes!" then there's an opportunity to do some great personal work. Work as a creative force. Work as an actor. Work as a conscious being.

Right now, in this very moment, do you feel like an actor *or an artist?* It's a really great question to ponder throughout your day and activities. The evolution of that mind work will ultimately serve you in your choice to be or not to be in theatre. And ultimately, your audition freedom.

AUDITION MIND TOOL: LITTLE INVESTMENTS IN YOUR ARTIST BANK ACCOUNT

Rather than think of auditions as something more akin to tooth extractions without Novacaine, rethink all of your audition experiences as little investments into a very special virtual bank account that sums up the debits and credits of your actorly endeavors. Here's some interesting math to consider:

I'm going to establish that because you are the only version of you on the planet, that you start out with a net worth of $1000 in this account.

Next, let's assume that you do one audition every two weeks on average. That seems more than reasonable based my experience of professional actors in NYC who are truly committed to a career and making their living as artists. That means you would do 26 auditions per year on the average. Subtract 6 for when you're sick, have conflicts or are not-in-the-mood. Since you're brilliantly marketable, committed and talented, let's subtract another 5 for the ten weeks per year you work out of town. We're now at a very modest 15 auditions per year.

Piece of cake! Now, let's assume that you sock ten bucks into a savings account every time you audition.

So far for the first year we've got: $1000 + (15 x $10) = $1150

But wait! Here's where it gets good. By working and auditioning, you start to build a network of people who know you, can reference your talents and are more willing to hire you. That's like interest (we'll lowball it at modest 3%) and we know you'll continue making these investments for more than a year because you are on your artist journey and no one can derail you from your choice.

So that brings up and interesting idea when you consider compound interest:

Year One: $1184.50
Year Two: 1374.53
Year Three: 1570.27
Year Four: 1771.88
Year Five: 1979.54

Year Six: 2193.43
Year Seven: 2413.73
Year Eight: 2640.64
Year Nine: 2874.36
Year Ten: 3115.09

Holy Cannoli! I know I'm being corny, but my example holds true. With very little effort, you would triple your career investment *just by showing up.*

That's the nuts and bolts of auditioning, really. Heck, that's the nuts and bolts of life!

The more you do it, the better you get at it. The better you get at it, the faster people will trust you (and your talent) and take a chance on working with you. Also, you'll learn so much along the way that you'll find yourself better equipped to use your time and resources wisely when investing in your future artistry with things such as training, business promotion and pure enjoyment. Suddenly, you'll be in action towards a fulfilling life and career that provide you with the creative options that serve you. With more committed action rather than pure luck, you'll get more and more of the financial rewards that you deserve for your commitment to showing up.

Are there blips along the way? Sure. It's all ebb and flow. Some folks say "feast or famine," but I encourage you to ban that horrible idea of lack from your vocabulary!

The bottom line is that by committing to showing up, you build momentum and growth in your artist self, your creative future and your personal sense of value. Show up big! If you integrate that into your daily work, practice, politics, spirituality, training, world view, relationships, whatever—you'll begin to see measurable and totally quantifiable results!

"The Greeks gave us the most beautiful word in our language: the word 'Enthusiasm' from the Greek En Theos, which means 'Inner God'."
— *Louis Pasteur*

GET OUT OR STAY TO PLAY

Theatre requires great energy and great enthusiasm if it is to be your livelihood and life's work. Don't let my sense of irreverence and banter diminish the fact that much of it is discipline, consistency and focus. You know that. I know you know that. There are infinite possibilities for you to be creative and prosperous in your oh-so-short time on this planet, so it's worth a little thought to make sure you are on the right track. Are you making the right choices to feed your soul?

One of the exercises I do in my casting workshops is to ask my students how they see their life one week from now, one month from now, six months from now, one year from now, five years from now, ten years from now and a whopping twenty years from now. I ask them to write out a full page for each increment.

You should see the sweat start to trickle down their foreheads from the sheer anxiety bubbling up to their brains! Twenty years? You've got to be kidding!

I'm not.

It really stirs up the "stuff" for women in their thirties who are plugging along with their acting careers and suddenly have to factor in the desire to have children and the ticking clock. Your life as a human and as an artist is not just about getting opportunities to perform. You have to navigate the business side of things and still manage all that

we have to manage as adult Americans in the 21st century including retirement, health care, relationships, politics, spiritual matters and family. Rather than run screaming to a bottle of Southern Comfort, a dozen Krispy Kremes or your left over stash of pain killers, I encourage you to be still with the idea of gentle kindness towards yourself in your decision (at this time) to be an actor.

Always remember that you can change your course at any time! You can take time off to do volunteer work in a third world country, have six babies, hike across Australia—you name it. Show business and theatre aren't going anywhere. It may change and require some time to reacquaint yourself to the community if you leave to do other things for a while, but it's always available to you when you decide to return.

You really should feel great about your choice to do theatre. If you don't, don't do it. Don't spend all your time and energy on this theatre thing when you could be doing something else. Stay to play or get out!

Fine tune your subconscious dialogue and do a little check-in to see if it all feels "right". Even when you aren't on the stage or in a classroom doing the work, you should be at ease with the choice to do theatre. Every audition should be a big neon sign that says, "You belong here!" Sure, some auditions are total stink bombs. Sure you may have periods of questioning. I like to think of them as flat tires on your road trip and I think sometimes they get us off the expressway to enjoy some different scenery and surprising adventures if we relax into them.

Getting lost can be half the fun of getting clear on where we were going in the first place!

AUDITION MIND TOOL: TRUST YOUR GUT — 20 IMPORTANT QUESTIONS

Take a deep breath and relax your body from your feet upward all the way to your head. Be aware of relaxing everything like the arches of your feet, your inner thighs, your fingernails, your tongue, your temples, your scalp. All of it.

Keep breathing!

When you feel alert but relaxed, mentally answer the following twenty questions with a "yes" or "no" in your mind. Don't move to the next question until you are sure of your answer. Listen to your body. Trust your gut. There are absolutely no right or wrong answers in this exercise! Just remember to be clear about your answer before moving on to the next question. Don't write anything down—just visualize a clear "yes" or "no."

Choose one or the other. "Maybe" doesn't exist here…

1. Do you feel talented?

2. Do you feel successful at this moment in your life?

3. Do you really, really, really love theatre?

4. Are you willing to do the work and enjoy the process?

5. Does the thought of performing on stage always make you smile?

6. Are you happy right now pursuing an acting career?

7. Can you imagine doing something theatrical twenty years from now?

8. Are your basic needs being met with regard to your quality of life?

9. Do you have a survival plan that you can live with when you aren't working as an actor or are you willing to create one?

10. Do you feel prosperous as an artist?

11. Are you at peace right now?

12. Is there something you don't want to admit to anyone that you would rather do instead of acting?

13. If you left the biz, would you feel like a failure?

14. Do you trust that you are in alignment with your creative destiny right here and now?

15. Do you feel empowered in the world as an actor?

16. If you were told the world was ending in five minutes, would you regret the time and energy spent on your theatrical endeavors instead of other possibilities?

17. If someone offered you a million dollars to never perform again, would you take it?

18. If you never become rich and famous, but steadily have opportunities to pursue your craft, would you feel content?

19. Is respect for acting and a career in the arts a deal breaker for your current or future life partner?

20. Do you feel bright, energized and happy right now having answered these questions?

Relax here and keep breathing.

There is no scoring to be done—no report cards to burn. Just some space to breathe and think, breathe and not think. Just let all the answers dissipate and dissolve into a feeling in your gut and pay attention to it. I guarantee that whatever you experience at that deep, inner place will be valuable to you and your future creative choices.

"I am my own experiment. I am my own work of art." — *Madonna*

SHOULDN'T THE WALLS BE PADDED?

One of the things I love is the animation that actors bring to retelling their audition experiences. Theatre is war stories. No one talks about when they were brilliant or everything went perfectly—hell, no. Get a bunch of theatre folk around a table with some adult beverages and the wacky tales will spew forth of all the totally crazy things we have all done at some point or another inside the audition room.

Certifiably insane things.

Whether you consider yourself more like Nurse Ratched or more like Randall Patrick McMurphy, the lunacy can be the same.[5] And sorta fun, to tell you the truth. Remember when I told you that you could suck and still book the job? I'm not going to back down from that statement, because it's true, but the odds are in your favor of getting people interested in your work if you handle yourself well and have great auditions.

That probably elicits a brilliant response on the order of "Duh." Yes, I know you know that on a cerebral level, but the majority of auditioning actors haven't the foggiest idea what that means in practical experience. There are folks out there who audition constantly, but who never cross over to the interest pile.

If I had to pick the top five things I think add up to spectacular auditions (talent assumed), I would say the best auditioners are a

5 If you don't know these references, PLEASE go read *One Flew Over The Cuckoo's Nest* by Ken Kesey or at least watch the 1975 film starring Jack Nicholson so you can get into the cool kid's club that can talk about more than *American Idol.*

wonderful blend of confidence, presentness, authenticity, preparation and humor.

What is audition confidence? Audition confidence is walking into the audition room with a shopping list of possible unknowns and knowing that you'll be fine. It's a welcome mat in the doorway to challenge, problem solving, research, craft, wellness and joy. It's checking your ego at the door. Confidence is having nothing to prove to anyone and knowing, really knowing, that auditions are not a competition, but rather an offer to play. It's the excitement of knowing that every audition is the chance to do one of the things that you are here on earth to do today. It's knowing when the people behind the table are brilliant and when they're a bunch of loons and learning not to take either set too seriously. It's freedom from doubt. Audition confidence is making the choices you want to make and then living with the result. Confidence is not false bravado, but an artistic comfort that comes from inner trust—it is built from presentness, authenticity, preparation and humor.

What is audition presentness? Audition presentness is breath. It's learning to stay in your body and resonate awareness through vibrant emotional choices. It's the sparkle in your eyes when you lose yourself in the reality of an infinite sky, a lover, a dream—only to return to the audition room a minute later when your work is done. Presentness is flipping "the on switch" to all your sensory gifts and leaving the lights turned on. It's relishing the now. It's connectedness to the world you inhabit, including the people in the room. It is being anchored to the earth, yet being buoyant and free. It's a place you find and never want to leave. Audition presentness is not being the wimpy flame of a candle, but rather owning the light you have inside that is as bright as the sun—it shines directly from authenticity, preparation, humor and confidence.

What is audition authenticity? Audition authenticity is knowing who you are, what you can do and what you are willing to dream. It's

walking into a room full of strangers knowing that you matter. It's saying things you mean and not pretending to be something you're not. Authenticity is your favorite way of being because it speaks from your soul. It's the credibility that comes from keeping your word. Authenticity serves you and everyone around you so that you are in alignment with the best possible outcome for everyone. It's integrity derived from consistent courage in doing all things that demonstrate kindness to our fellow artists and truly intending them. Audition authenticity is not another role to play, it's the inner core we aspire to bring forth so that everyone around us is acknowledged, appreciated or transformed in our never ending journey—it is discovered through preparation, humor, confidence and presentness.

What is audition preparation? Audition preparation is doing the work. It's taking class, taking notes, taking time and taking care of yourself. It's activity leading to skilled behavior so that your artist self is equipped with all the tools it needs to contribute powerful, truthful stories to the world. Preparation is a commitment to the journey. It's discipline. It's trusting process, knowing that it leads to results. It's reading the fine print of your dreams, goals and prayers and translating all of it into clear, committed action. Audition preparation is leaving every excuse to fail in the trash bin and just showing up to the party. It's readiness to deliver the goods. Preparation is not mindless checklists, but rather specific choices made in service to the big picture of your artistic life—it is best friends with humor, confidence, presentness and authenticity.

What is audition humor? Audition humor is learning to love the roller coaster ride. It's willingness to play, laugh, trip, spit, choke and walk out of the room with an uncooked omelette running down your face. It's giggles. It's lightness in your heart. Humor is the wit beneath your wings when you are flying through a thunderstorm of negativity. It is your ally, your protective charm, your champion. Humor will never let you down when you need it and will always answer the phone when you call. It is your single greatest asset in your artistic life and

you must do everything to nurture it. Audition humor is not an award winning performance—it is the spotlight on your life's work when you look around and see that the only people left in the audience are the people who were forever changed because of your confidence, presentness, authenticity and preparation.

Confidence. Presentness. Authenticity. Preparation. Humor. Invite them to every audition and see what happens.

"I'm sexy already, thank you."
— *Queen Latifah*

BIG GIRLS ARE SEXY — AND SO ARE YOU!

I love Queen Latifah (a.k.a Dana Owens). If anyone deserves some serious acknowledgement, it's her. She's talented, cool, down-to-earth and she loves who she is right here, right now. She creates her own opportunities and does what she wants as a performer. She's not waiting to be happy until she wins an Oscar or when she sells a a million albums. She makes fun movies, she makes some bad movies, she can rap and she can sing jazz. She loves to make people laugh and she loves being beautiful. Curvy, real woman-esque beautiful. A total knock-out on every level. She's not trying to aspire to size-two-heroin-chic like some of the gals you'll find in the fashion magazines. She's livin', lovin' and doin' her thing—which is why everyone adores her.

I don't care what it is (if anything) that you don't like about yourself, but realize that everyone has some place in the biz. Some have more opportunity than others based on type-specific traits, but nothing is ever set in stone.

Every single actor (if not person) I know has at least one (if not ten) things that they think they have to fix when it comes to their physical being. Considering it's a huge part of what you're bringing to the casting circumstance, you better find ways to embrace it, change it or get over it. I'm about truth and diplomacy and that's as simple as it gets. Do what you need to do to feel like you don't have anything interfering with your audition freedom. If you want to be a beefcake, hire a personal trainer and go to the gym. If you don't like your teeth, spend the money to fix 'em. If you think your penis is too small… oops. Strike that.

AUDITION FREEDOM

I want you to laugh a little and realize that you're human and we all have some of that specific chatter about our bodies and looks trying to call us down a wicked psychological path. You can buy boobs, suck you're your fat out through tubes, put pads in your butt and you're still not going to feel great about yourself if you don't work from the inside out.

Work on the chatter or work on the things you can take action towards (including your mental state of health) so you can get to your deepest work as an actor. This includes all the physical tangibles and the psychological intangibles that play into the casting circumstance.

Will a twenty-one year old with a genetically perfect body, no pores, perfect teeth and camera-friendly cheek bones do well? Probably at the beginning. Certainly, people will respond to them and they will have an edge over most of the population in booking soaps and film. Great! Bless them and their DNA strain and realize it's not your journey. If it was supposed to be your path, you would have been molecularly designed that way.

If you're battling any kind of eating disorder or self image problem, get help. Plain and simple. Talk to a friend, read a book or hit the internet and find a resource to help support you. It will kill you sooner rather than later and you might have some very big things to accomplish on this planet that will serve all of us. I'm being totally selfish, but I'd hate to miss out on whatever you're bringing to the theatre world (or the rest of the world) just because you left us too early!

We need you.

If you are comfortable in your own skin, then we'll be comfortable when you are in the room auditioning and everyone's possibilities will expand. Just chill out and be good to yourself.

"We collect data, things, people, ideas, profound experiences, never penetrating any of them...But there are other times. There are times when we stop. We sit still. We lose ourselves in a pile of leaves or its memory. We listen and breezes from a whole other world begin to whisper."
— James Carroll

SMASH THE MIRROR

There are a lot of ways we can try to manipulate and feel in control in the audition room. Unfortunately, they are all like some short lived recreational drug—anything from a hit of ecstasy to a jelly donut. They feel good for a second and then in the aftermath, they make us feel worse.

It's natural. Anyone who doesn't admit that walking into a room full of strangers, without rehearsal and sharing a personal, soulful story that taps into our innermost well of being isn't something to be reckoned with is full of, well—bull pucky. However, the thing I know to be true from the bottom of my heart, is that if you really take the work seriously and trust all the things that you bring to the plate, it can be quite transformational for everyone involved. Not always, but most often.

More importantly, you *allow space.* Space for the creative team behind the table to do their job and get to know you. Space for yourself as a human who has chosen to be there in that room at that moment. Space for everyone involved to trust being in integrity so they can get the job done in the best way possible. Actors who are free of manipulation in the room are not as common as one might think— and they are very, very castable.

AUDITION FREEDOM

There is a bit of a lottery going on in the professional theatre world each and every day. Regardless of agent appointments, pre-screens, open calls, callbacks—everyone wants to find the golden ticket. And they do. It's usually a person who walks into the room, has nothing to prove, isn't desperate, is fully prepared and interestingly enough makes no bones about being some sort of perfect. We LOVE imperfection. It's human. It's fun for us to watch imperfect characters work their shit out in front of us so we can empathize with the characters! Perfect characters make for dreary theatre and they drive me to eat jelly donuts.[6]

We are a glimmering facet of the world around us and that changes constantly. It's not some book that has been sent to print and can never be revised. We have to stay malleable. Flexible. Impressionable. We have to be like a big wad of magical silly putty that never gets dirty—and that takes continuous renewal.

It's the way of the enlightened warrior. No gripping onto ideas about "rules" or how things should go. Creating a sensibility of gentle strength that you are there to do what you must do. There is no other option and the outcome is far less important than your mission to be there. Tell your stories and relish them.

Let the people behind the table do what they have to do and if it becomes a reality that you share that particular part of the journey, so be it. If not, so be it. By focusing on your work, preparation and celebration of what you are doing, you will instantly create energy towards your goals. I guarantee it. I have watched people walk out of my workshops after one week and book huge gigs because of one little perception shift in their work.

6 My addiction really isn't jelly donuts. It's chocolate frosted old-fashioned cake donuts the diameter of a coffee can that they make in the Midwest which are covered with buttercream frosting. I don't know who came up with the idea that birthday cake was an acceptable form of breakfast, but if I meet them someday, I may consider the dark side. I'm really, really grateful they aren't a regional taste preference in NYC or I'd be in serious trouble!

The shift was a new awareness and commitment to be nothing but who they are at any one given moment—knowing it could *and would* change. There are no absolutes in the show biz world and why would you expect them? There are no absolutes in the world at large. It's lunacy to think things would be different in our little pond of theatre believers.

My personal goal is to keep the pond healthy and green. Full of life that supports its ongoing existence, rather than allowing the pollution of a few to destroy its delicate ecosystem. I believe it's time for a mind tool! One of my soul mates on this planet is an environmental engineer and attorney for the EPA who spends considerable amounts of time focused on corporate lawsuits that demand ecological awareness and cleanup. She happens to have married another environmental engineer and they both rely in some way on "sampling." They get soil, ice, sediment, or water samples, sometimes very deep in the earth or bottom of a lake and research them for immediate and long-term implications to the environment and ecosystem. Believe it or not, I'm going to apply this to your audition life.

I hope by now you realize that I'm having some fun wiggling around your brain with every sort of offbeat analogy that can get you to look at the audition circumstance with fresh eyes. I also want you to free yourself up from living in a theatrical world full misconceptions that don't serve your artistry. That being said, let's go diving.

AUDITION MIND TOOL: YOUR WATER RETREAT

Read through this exercise completely and then do this visualization no matter where you happen to be reading. Let it be about noticing things. There is no right or wrong way to do this exercise! You might want to revisit it on occasion to see what you differently later on.

AUDITION FREEDOM

Choose an image of a simple, beautifully natural habitat near a large body of water that you enjoy. It can be real or it can be totally imaginary—like the landscape of some far away world in a children's book. A gentle forest, a white sandy beach, a riverbank. Just be sure that you can visualize a body of water nearby. Look at this body of water and name it after yourself. It could be Leslie Lake, The Sea of Salisbury or Kurtzuba Pond. Have fun here, but pick your very first instinct. Notice what body of water you are instantly attracted to and how you feel about it.

Now, becoming aware of yourself and the body of water, walk towards it and slowly make your way along its edge, getting familiar with its relationship to the land. Are there waves, rushing water or no movement at all? What do you hear? Is there a gentle breeze? Is it hot or chilly, sunny or in complete shade where you stand?

When you feel ready, turn to your body of water and step into it. Is it warm, cold, turbulent, peaceful? Notice the details of the water itself. What are you wearing? Are you in full scuba gear or completely naked? Notice things. When you have become accustomed to the feel of wetness around your feet, walk further towards the center, descending until the water is waste high.

Look down at the water. Is it cloudy and hard to see to where your feet reach the earth? Is there life around you? If so, what kind? Do you feel safe or anxious? What kind of wildlife, if any, do you notice and how do you interact with it? Are there thousands of small fish or is there a large shadow moving in the distance?

Since this is your magical world and your exclusive body of water, gently submerge yourself below the surface, knowing that you will be able to breathe. Look at the underwater world and see how far your vision allows. What is in the distance? Do you feel like you want to stay and explore or get back to the surface? Notice how you feel about everything you can see or touch or sense.

Touch the earth below your feet.

Is it rocky, sandy or slimy? What do you notice about the soil or sand? Run your fingers through it and see what you notice. When you feel satisfied that you have noticed everything you need to notice, gently appreciate your underwater world with one last look and turn away to face the shore. Stand and walk slowly towards it, noticing each and every part of your body as it emerges from the water. Keep walking until you are completely on land and turn once again to look at the lake, pond, stream, or ocean.

As you turn, you'll notice a large white, blanket or towel. As you look at it, you are amazed to notice that it radiates a gentle blue-white glow. You walk over to it and pick it up, only to find that it is warm. As you wrap yourself in this yummy, magical gift, you notice that the warmth reaches every part of your body and you feel completely at peace. It is a beautiful day as you ponder your journey, wrapped in this brilliantly white blanket, so you sit down and look at your water retreat and ponder all the wonderful life that lives there.

Life is good.

"Be impeccable with your word. Speak with integrity. Say only what you mean. Avoid using the word to speak against yourself or to gossip about others. Use the power of your word in the direction of truth and love." — Don Miguel Ruiz

SLICKSTER CENTRAL: STYLE OVER CONTENT

When someone asks you to be yourself, what does that mean to you? Is it easy or does it bring a chill to your inner bone marrow?

It gives me a giggle how many actors struggle with just being themselves instead of playing an idea of an idea of an idea of themselves. It's not a surprise, really, when we spend most of our creative life force being a vessel for other people's characters. It takes considerable trust not to put on a slick interpretation of what you think "they" want to see. Ironically, this interpretation is so transparent that it becomes tedious. I've met so many actors socially in various settings to find them charming and full of shining personality only to bring them into an audition to see the Terminator and his Stepford Wife walk through the door. I've literally stopped people in the middle of a side or song on many occasions to jolt them out of the bizarre, stifling manipulation they were putting on that was hiding all the things I loved about them. The very reasons I had brought them before the creative team in the first place!

It's an easy analogy in this day and age of digital, well—everything. People walk into the room struggling or simply forgetting to be present, with a barrage of imaginary recording devices circling them. The mega-pixel self-deprecating cameras, the cerebral iPods blairing negative chatter, the digital high density microphones blaring the DVD

of how they think the experience should go, etc. Most of their artistry is used up trying to be engineer to all this imaginary equipment, that actual storytelling and truthful performances are lost. And then the creative team has already moved on to the next possibility.

How can we cast you like that? Unless you have something extreme to offer (height, weight, age, money notes) that we are desperate for, there are a thousand other folks who will walk in the room and not be afraid of imperfection. It's much more interesting in the long haul. It can even pass as brilliant acting. True!

The trouble with being a skillful slickster is that it may have served you quite well up to a point. You actually may have seen a substantial amount of measurable results from your approach, knowing deep in your heart that you were manipulating everything about your way of being in the room and the stories you were sharing through your work. Here's the caveat: You'll hit a wall and never move beyond it. You may have already experienced this and it's one of the things that created a desire to read this book. You may have gotten feedback from friends, agents, or other industry folks that somehow supports this idea on some level and haven't wanted to deal with it.

It will show up in other areas of your life.

If you find yourself not being present, truthful, integrity-driven and authentic in your work as an actor and artist, you will ultimately do so in your life. Our lives and our artistry are one and the same. They are not two separate lives that never coexist. Much the same way—whether we admit it or not—every character we breathe life into is not some foreign entity, but culled from our personal life experience and inner truth.

Bottom line, you are your artistry. Your manifestation in life is also the work you do in the room. Prepare and choose carefully your way of being. Of course, everyone wants you to be professional,

charismatic, charming and talented. The next step, and the one I deal with constantly at the Broadway level, is owning your human experience and translating that into the work. Bring the good stuff into the room and leave the rest outside the door to work on in your personal life. *Do the work.* Both as an actor and as a human. When we stop learning new things about ourselves, the world around us and what is possible, we die.

Do not settle. Do not give in to apathy and indifference. Percolate on the things that will allow you to be totally present in your audition. Interestingly, they all come with you into the room from your other areas of your life. Your experience. Your now. How can you do this?

Expect good things.
Live juicy.
Embrace new ideas.
Read many books.
Relish poetry.
Walk in nature.
Draw with crayons.
Give the picture to your best friend.
Do your best.
Make big mistakes.
Roast marshmallows.
Champion your friends.
Look for smiling people.
Receive gifts.
Travel a lot.
Get lost sometimes.
Say thank you.
Write letters.
Forgive your family.
Make tons of money.
Enjoy good food.
Get wet once in a while.

Protect your friendships.
Savor sunlight.
Savor rain.
Make friends in coffee shops.
Take naps.
Tell the truth.
Smell flowers.
Watch animated movies.
Make your own wrapping paper.
Take care of our planet.
Have great sex.
Learn how to play guitar.
Swim in the ocean.
Turn off your cell phone for a day.
Speak kindly.
Ready yummy books.
Let puppies lick you.
Remember where you started.
Give up the need to be right.
Play with children.
Taste snowflakes.
Cherish the elderly.
Bake your own birthday cake.
Lick the frosting bowl.
Create moments of solitude.
Eat fresh, living food.
Choose some joy everyday.
Send anonymous gifts.
Be generous with your compliments.
Live in the wonky place.

"Live to the point of tears." — Albert Camus

SIMPLE SELF TRUTHS

If you are really committed to yourself as an artist, you'll know what you are here to do and what you need to say. If even a single page or two of this book does it's job, you've opened the door to that new possibility or affirmed more of what was already in place in your artistic life as an actor. The stories of your journey will become the crossroads for others making their way and so it goes, on and on. We breathe, we create, we travel. We do some big shows and we do some little shows. We'll play Othello in a storefront for no money and then find ourselves playing a dancing fork on Broadway. I love theatre! We meet and hang out with some good folks. What more could you ask for? I can't wait until the day I get to meet you in person!

There is no escape from the human experience. Theatre, however is a choice for you to be in that particular experience. Listen to your inner voice and just keep moving in alignment with the gentle truths that your heart reveals to you, not the lies that rage from your ego. It's all quite simple and yet takes a bit of life experience to integrate.

There's a lot to be said about journaling. For those of you who are totally bent on doing everything the "right" way, this should be a priority. There is no right way to write in a journal. It's a great exercise in release, flow and learning not to censor. Be sure to do it with actual writing instruments on paper—the computer loses all the sloppy, messy, random passion and inspiration that the activity of writing brings forth so that you can lose yourself and find yourself. I once accused my best friend of writing comments in my journal. We were living together and I couldn't believe she had violated my inner spew of written word. Now, she is not one to ever lie and she laughed me

off. I kept on about it and finally went back to the journal, writing out comparative phrases, to realize it was really my handwriting, albeit haphazard. We both have similar cursive writing, so it was an interesting mistake and discovery on my part. *I had absolutely no recollection of writing the inserted text.* None.

Upon closer inspection, I realized all the added notes and commentary really did sound like me and it ranged from diamonds of brilliance to piles of horse poo. Welcome to the idea of a perfect journal! It's a lesson in futility that will educate you, frustrate you, inspire you, heal you all the while bringing your dreams and fears into focus through the power of words. Oh, and be sure to lock it up.

AUDITION MIND TOOL: JUICILICKITY ADJECTIVES

My goal for this book was to keep it breezy-fun and require very little effort from the reader to create perception shifts towards auditioning and empowerment as an artist who has chosen to be a stage actor. Just some sixty-second brain juice now and then to keep the machine rolling.

In keeping my word on that, I've translated one of my favorite journal exercises to you into a thought format. I use it a lot when I'm coaching actors, preparing text, getting clear on personal goals, pitching projects or jotting down notes on someone's audition. I'm a huge fan of juicy adjectives. I'm not talking luscious, I'm talking *ambrosial*. Do you get my drift?

Good. I want you to rack your mental rolodex and pick five right now. Five spellbinding, provocative, entrancing, prepossessing and

juicilickity[7] adjectives that describe yourself as an artist. Can you do it? Furthermore, can you memorize them?

You didn't really think I'd stop there, did you. This book is about audition freedom and that freedom comes with a price—the Swan Song of your ego.

I dare you. No, I *double-dare you* to completely own all five of these adjectives at your next audition. If you're the over achieving sort, feel free to tell a friend.

It's all part of the thoughts-are-energy-that-become-reality-quantum-physics application I've been hinting at that cannot be denied.

Don't even think about turning the page until you can integrate your five rapturous adjectives into the following statement:

I am a _____, _____, _____, _____, _____ artist!

Now repeat that completed adjective-y sentence in your brain a few times to lock it down. Oh, just for the awesome fun-ness of it all and your commitment to play with me, say it aloud once before you turn the page.

7 Yes, I made that word up. Creative license—you think I'm a fool? It's fun to say and I don't remember the instructions dictating that the chosen words require a formal entry according to Webster. Hah!

VP BOYLE

Yes, you are!

VP BOYLE

PART THREE

DOWN THE RABBIT HOLE

VP BOYLE

"There is no use trying," said Alice; "one can't believe impossible things." "I dare say you haven't had much practice," said the Queen. "When I was your age, I always did it for half an hour a day. Why, sometimes I've believed as many as six impossible things before breakfast."
— Lewis Carroll (Alice in Wonderland)

IMPOSSIBLE THINGS

The quote that prefaces this section is one of my favorites of all time and keeps me unstuck on so many levels. It's one of the great reasons I've pumped this book full of quotes from authors, poets, icons, scientists and enlightened masters. Words have great power to manifest in very tangible ways and this little passage of text offers an interesting theory to begin each day.

Why can't we believe impossible things?

There's a very interesting element to Lewis Carroll's story. Our sassy little anti-heroine, Alice, doesn't grab or claw at the roots that she sees as she is falling down the rabbit hole (really, a well inside the rabbit hole) to try to stop herself. She falls freely, simply looking at the things around her as she descends past cupboards full of interesting objects like pictures, cups, even a jar of orange marmalade. There is no fear involved. Just pure, unfettered observation.[8] I never realized that!

8 Years of recovering Catholic guilt would bubble up in my psyche if I didn't credit Pema Chödrön for this astute and divinely inspired observation about Alice. She is this super cool, down to earth Buddhist nun that introduces Westerners to Zen philosophy, teachings and meditation. Check out *When Things Fall Apart* and *The Places That Scare You* among her other titles.

Alice just takes it all in and finds herself in a new world of total wonder with the chutzpah and curiosity to explore it without a second thought. The thing I love about *Alice in Wonderland* and *Through The Looking Glass* is that Alice really finds her way to adulthood by learning how to absorb, interact and communicate through discovery in her magical world.

Isn't that what we do as artist/actors?

We study our patooties off in every type of discipline to become the best possible vessel for exploration in whatever theatrical genre that speaks to us. Auditions are part of that magical world. They are artist moments that are chock full of surprise. A chance to "do our thing." A chance to trust that we can have magical adventures and can make wonderful discoveries without getting hurt. Sometimes you may feel like you're falling down the rabbit hole, but you still have permission to look around and see what's around you. Alice was a sassy gal in that respect. She had her shit to solve, but she took it on and never once looked back.

I love how she committed to things once she made up her mind to do something. She invested in her journey and saw some great rewards—namely freedom from adolescence and coming into her own true self.

Have you ever considered that auditions, as part of your artistic journey, are a chance to come into your own true self and evolve as an artist? Something to embrace? Something to welcome? Something to look forward to?

No, I'm not on crack.

Wrap your mind around the idea that auditions are artist moments to focus your creative energy, not some dog and pony show. Focus on what you might discover about yourself and your soulful storytelling

and focus less on pleasing some stranger behind a table who is reading your resume!

Don't get me wrong, auditions are not my favorite part of theatre. The rehearsal process and creating new work makes me as happy as a clam. It's my favorite thing in my theatre life and I do it for free when the project is juicy! However, I embrace all the little investments and discoveries I make in the audition room as well.

Those little "audition moments" can add up to immense artistic investments simply outside of the "get the role/contract/job" equation. Even better, they don't all have to be knocked out of the park to score a home run for your professional career. They can range from inspired brilliance to eggdrop soup, but it's all added value in your life journey as an artist that will increase with interest to serve you later!

"Dream as if you'll live forever. Live as if you'll die today." — James Dean

ON THE DECK OF THE TITANIC

Somewhere along the line, someone gave me a piece of advice that I'm going to take to my grave. For the life of me, pun intended, I can't remember who it was—ah, delicious irony. What was this piece of sage advice?

You can't stand on the deck of the Titanic and try to hand everyone around you a life jacket.

The point is that to help others, you have to take care of yourself first. You're no good to the world if you're not here to participate in the natural unfolding of the universe. If you are trying to buoy everyone around you (parents, friends, lovers, spouses), there will be nothing left for you. On the other hand, if you take care of yourself, create a sacred home and truly commit to your own personal safety and wellness, you suddenly become extremely available to others to offer much more in terms of supportive output. *We're talking gifts.* Great gifts that inspire others, promote healing and champion new possibilities—all the human spirit stuff. Theatre people can be bright lights in the big city and I'm not talking about neon. I'm referring to the societal shifts created by powerfully committed artists who shine as conscious beings.

That includes you!

I think art and artists heal our planet. Just think about the legacies of Beethoven, Shakespeare, Da Vinci, Picasso, Whitman, Chaplin, Disney and more.

As artists, we matter.

The struggle in this distorted view we have of giving everything possible emotionally, physically, psychically, mentally and spiritually until we're totally depleted. Now I'm well aware that this doesn't pertain only to actors, but it's a paradigm that is hugely prevalent in the artistic community that you should spend time considering. If you fall into this trap, save yourself and do it now. Find the first aid kit for your artistic wellness and make sure you keep it fully stocked so that you can bring it with you to every audition. You should feel energized and full of life when you do your work, not drained and depressed.

The idea of an artist first aid kit is nifty because it could include all the things you know you need to feel great, no matter if those things are tangible or imaginary. They are your elixirs of life, your secret remedies, your wonder drugs. It doesn't matter what other people think you should do to feel good, since only you really know. Feel free to ask people you trust for advice, but in the end you are your best advisor for all things relating to your audition wellness.

Let me state quite clearly, for the record, that I'm using an analogy here and not referring to actual mental health issues or physical ailments that require medical attention by health care professionals! It is important to remember that one part of the responsibility of taking care of yourself is knowing when to seek proper medical advice and treatment. If financial struggles are keeping you from responsible healthcare, I strongly encourage you to contact The Actors' Fund or other private and governmental agencies to find out what options are available to you. They will find a way to get you the services you need or steer you in the right direction no matter where you live.

If you're wondering what the heck I'm trying to communicate, here is my personal example of what my latest travel "audition first aid kit" includes:

1. Ten hours sleep. Non-negotiable.

2. Really nice, yet comfortable shoes. It took years of experience to realize that when my feet are happy, so am I.

3. A leisurely light breakfast with fresh berries somewhere on the menu. I consider fresh berries a ceremonial treat and never skimp on them.

4. A silver ring that I wear that looks like a crown. It's my personal talisman to remind me that I am the king of my creative universe and no negativity can steer me from my greater good.

5. Perfectly pressed clothes that make me feel fantastic.

6. MAC Fast Response Eye Cream. I just turned 40!

7. MOTIVES Custom Blend Foundation made just for me that I use as a concealer. Some days are better than others (see #6).

8. Some inspirational reading material such as Pema Chödrön's mini-book, *Awakening Loving-Kindness*, which illustrates quite brilliantly how I can acknowledge my entire experience with loving kindness rather than negative self-abuse.

9. Anti-histamines because I'm allergic to everything and it makes me feel safe to always have those pink little pills with me—one never knows when I'm going to eat something that makes my lips blow up like Goldie Hawn's post-collagen-injection scene in *The First Wives Club*.

10. A cut-n-paste montage tribute (that I have glued all over the inside of my audition book) that is made up

of pictures of my best friends, family, favorite mantras, silly clippings, sexy icons and more—including my new code word WOOF to encourage me to playfully "Bring it on!"

11. A quote sheet given to me from my students of the crazy things that I always say which make me laugh (and laugh hard). It is one of my prized possessions.

12. Fantastic pictures that really look like me.

13. A bottle of pure water in my bag for later.[9]

14. A raw food granola bar in my bag.

15. Songs and monologues that I've chosen very carefully because they are stories that speak to every molecule of my being. I always feel like it's a gift to share them.

16. A really nice pen and my journal full of rants, raves and crazy ideas. This book started in one of them...

17. My favorite Shea Butter & Vanilla lip balm. I never leave home without it!

18. Twenty bucks that I use to have a nice, quiet sit-down meal after every audition. I give myself time to rest, rejuvenate and reflect on the experience—then I let it go.

9 We have a real problem in the US with plastic water bottles entering the waste stream, so I have purchased my own water purifier to fill the same polycarbonate bottle over and over again. A good one coats about $200 and pays for itself very quickly so that you actualy save money while being eco-friendly. Do something smart!

AUDITION MIND TOOL: YOUR DR. WELLNESS FIRST AID KIT

You can't really "stock" your personal first aid kit until you consider the things that might cause you to need it during auditions. When I went camping as a Boy Scout, we always had a snake bite kit. I'm glad to say I never needed it because it sort of freaked me out, but I guess it made sense for that type of outing. My first aid kit at home is really just some fancy band-aids and antiseptic ointments with assorted cold remedies thrown in for good measure. The contents are specific to the location. Hopefully your auditions won't involve any type of cuts, bruises or bleeding! If they do, I fear for you.

Since we're playing in imaginary-land, let's assume you are willing to play a "juicy role" since you're an actor committed to perception shifts and having fun in auditions. We'll call you Dr. Wellness. Cheesy, but fun. I feel I owe you something light and breezy after the twenty important questions in the previous Audition Mind Tool. Use your last 3-5 auditions as fodder for this mind game and we're going to hone in on three areas of concern regarding wellness that I feel are always prevalent in the casting circumstance. They are physical well-being, emotional/mental well-being and psychic well-being.

If you had to pick one recurring symptom from your past auditions that made you not feel good *physically*, what would it be? Examples might be shortness of breath, racing heart, clammy hands, shaky knees, facial twitches, sweaty armpits, or the urge to vomit.

Now, pick one thing to "treat" or counter that symptom/response when you are auditioning. FYI: Pharmaceuticals are not a part of this exercise! For instance, if you suffer from shortness of breath before you walk into the room, a great first aid remedy might be ten minutes of silent meditation before you arrive, a morning session of Tai Chi,

closing your eyes and repeating a mental mantra that you love, breath work such as Linklater Technique, etc. Get it?

Once you have isolated a *physical symptom* and it's corresponding remedy, move on to something that affects you *emotionally* or *mentally*. I'm sure this is where many of you might gravitate quickly towards ideas such as panic and fear, but I know I'm personally always helping actors with other underlying things like self-deprecation, trust and confidence. Brainstorm this one and really get creative with your imaginary "medicinal ointment." This is where some fun stuff can come to play such as symbols, tokens, or rituals. Maybe you have a special picture in your wallet of someone you adore or someone who is your champion. Maybe wearing your sparkly pink scrunchy is your secret symbol to invite good luck. Yikes, I think I just referenced *Legally Blonde*, but hey, Reese Witherspoon wins out in the end and she totally understands the idea of having fun, so there might be something valuable there.

Now on to the new-agey, funky part. Something that affects you *psychically*. By this, I'm referring to a symptomatic response at the soul level. Symptoms might include not being in your body, being a psychic drain to those around you (needing constant attention), taking on negativity from your environment, etc. As a remedy, I love endowing props (such as jewelry) with my own creative ideas about protection and cleansing. Remember I told you about my talisman—the silver crown ring? You could explore things like visualization techniques, an inspiring poem, a favorite prayer, or by wearing your personal blend of essential oils. Whatever works for you is the right thing to use! It's personal—it doesn't have to be shared, discussed, or negotiated. It's simply a way to explore things that you can make constantly available to yourself when you need them so you can set yourself up to have the best possible experience in the audition room.

Anything that serves you has value. Period.

"The world is not respectable...it is mortal, tormented, confused, deluded forever; but it is shot through with beauty, with love, with glints of courage and laughter; and in these, the spirit blooms."
— George Santayana

RAINY DAYS & MONDAYS

We all get blue now and then. Life can really throw us some curve balls. Shortly before 9/11, I decided to take a break from the biz because I was totally exhausted and burnt out. I had spent three years putting blood, sweat and tears into a nonprofit that was ripping some of my closest relationships apart. My acting career was testing me on every level and I wasn't really taking care of my personal health. When that horrible event sent the Big Apple into a total tailspin, I was on the front line at Chelsea Piers the same day with hundreds of other volunteers all struggling to help the families of the missing victims. They were truly dark days that followed for all of us and whether I like it or not, they have become part of my journey in this lifetime.

Little did I know that 9/11 would mean a year of total unemployment, political unrest, urban angst and recovery. There are thousands of stories that you will come across related to the World Trade Center, but the fact remains that if you were there to witness the events, you were changed forever. Amidst all the chaos, I was slated to direct a Broadway play that fell through in the midnight hour, one of my parents died and I was desperately trying to save some very close friendships which were in jeopardy. Yikes!

I won't bore you with the other personal details, but let's just say that on the major life event stress scale, I had knocked out enough to put me on the danger list for Bellevue's mental ward. Looking back,

AUDITION FREEDOM

I see my score was off the charts and it's clear that I, like many New Yorkers at the time, was dealing with pure post traumatic stress. There were days when the best I could do was get up, shower and breathe. I wrote in my journal and plugged along and gradually dug myself out of that dark hole through consistent personal work, but it wasn't easy! Thank the stars above that I didn't have any Carpenter's music in my collection—it would have gotten ugly. Was I able to do much theatrically? No, of course not. I was in survival mode, not artist mode. The idea of walking into a room and auditioning for a show was absurd. I directed one project thinking it would be fun and it nearly killed me. I knew I had to take time off so I went under my rock for two years. I got a survival job and started writing a lot. Not this book, of course. It would take five more years of avoidance before I got past that chatter in my brain to get here with you.

I'm actually very grateful for that period of my life and everything it taught me: that I can survive, that I can heal myself, renew, reinvent, recommit and remember who I am and why I'm here. It's all good! You can do the same thing at any time. Remember that and keep it in your pocket of certainties so that you can remain upbeat and vibrant when you take on all the personal work necessary to be better in the audition room. The point is that when you need to take care of yourself, *just do it*. If that means therapy, go to therapy. If that means a year of chanting at the top of a mountain—go chant. Seek out holistic support or dive into Western pharmaceuticals if they work for you and keep you out of danger. Do whatever you need to do.

Life comes first. Before show biz, before auditions.

Do not consider anything you choose to be right or wrong. What do those words really mean? It brings us back to the idea of ebb and flow. Spend even an hour on any ocean shore and you understand the profound greatness of it all. Want to get your priorities straight? Hold a sleeping infant or visit the Great Redwood Forest. Walk the western rim of the Grand Canyon and then come tell me that auditions and a

career in the acting profession is cause for any distress or personal drama.

The fact that you may have to walk away from the theatrical world now and then is not failure—it's choice. It's your responsibility to staying on this planet and to having a life that has value. It's a commitment to inner artistry and wellness. When you look in the mirror every morning, greet yourself with the knowingness that you get to choose the red pill or the blue pill. The day is a blank canvas and you are the artist who was meant fill it through infinite choices. And don't listen to Karen Carpenter when you're blue—classic Madonna is so much better.

"Your time is limited, so don't waste it living someone else's life. Don't be trapped by dogma — which is living with the results of other people's thinking. Don't let the noise of others' opinions drown out your own inner voice. And most important, have the courage to follow your heart and intuition. They somehow already know what you truly want to become. Everything else is secondary."
— Steve Jobs

THANKS FOR SHARING!

How much of your day is spent on self-abuse? I'm not talking about the obvious stuff like overeating, starving, drinking, stressing, smoking, drugging, raging, or running yourself into the ground. I'm talking about that incessant digital voice recorder in your frontal lobe that plays the role of critic and tells you that you are untalented, fat, ugly, stupid, poor, helpless, lonely, weak, blah, blah, blah.

Why do we do it? Why? Why? Why? Why? Why?

You should spend more time on figuring out why and working out strategies to stop it or transform it into something useful instead of letting it take control of most of your waking hours. We are our thoughts. I could publish an entire book of essays and quotes that say some version of that idea, but I won't because we need keep as many trees as possible on our planet right now.[10] Not to mention, Quantum physicists are discovering some pretty incredible things

10 I'm committed to earth friendly habits. So much so, that for every copy of *Audition Freedom* that is printed I will personally plant a tree to offset the carbon footprint through American Forests. Check them out at www.americanforests.org

about intention manifestation and the universal laws about energy (our thoughts) and you owe it to yourself to do some research in that area. I guarantee it will have an impact on your audition life.

It boggles the brain to wonder why actors, so adept at interpreting text into physical action, spend fruitless hours worrying about stupid shit that is all fiction. I'd love to sugar coat that in a different way, but if I met you when I'm on this tangent, that's what I'd tell you.

Plain and simple. *Stupid shit.*

It's all a waste of energy. Energy you need to utilize for your creative output. Energy you need to live the life you have right now, right here. Negativity that will kill you over time because the stress will ultimately infiltrate you at the cellular level and bring detriment or disease with self-fulfilling prophecy by your subconscious so you can be right. If that doesn't work, you will invite a host of other addictions that will speed up the process quite nicely. I don't want you to be right. I want you to be free in all the simple ways that can serve your wellness in audition life.

I'm not Mister Gloom-n-Doom and I'm not Mister Perfect. I have a list of things I'll be working on until the day I sing my way to the next realm—and trust me, *I'll be singing.* Let them throw a party on my behalf and dance until the sun comes up!

One day I woke up and realized I was tired of beating myself up and working too hard to please other people. I realized my purpose in life was quite simple: to have fun and trust that my journey is exactly that—my journey. I get to make my own mistakes. I get to fix them. I get to learn. I get to love. I get to fall down and pick myself right back up to look at my skinned knee. I get to live. Suddenly, everything shifted a tiny bit. Okay, I'm exaggerating. How about my world went from self-imposed struggle to full tilt boogie. Theatre became a treat. Directing was a treat. Acting was a treat. Casting was a treat. Teaching

was a treat. Singing was a treat. Writing was a treat. Coaching was a treat. Being an artist was a treat. Dancing still wasn't a treat, but that's because my knees and hips aren't what they used to be.

Are you ready for this? *Auditioning became a treat.*

"Decorate the rooms of your mind as you would a favorite retreat...with things that calm your spirit and fuel your imagination." — Suzanne Willis Zoglio

PUPPET PSYCHOLOGY

My students and coaching clients would shoot me down in broad daylight at the 7-Eleven if I didn't include my "Thanks for sharing!" puppet psychology. It's such a part of my coaching style and banter, that it was the working title of this book for many months.

I'm not the first to think of it, although I've been using it for a very long time in my work. I was just reading some inspirational stuff written by T. Harv Eker, author of *The Secrets Of The Millionaire Mind: Mastering the Inner Game of Wealth*,[11] and laughed aloud on the A train because he used it regarding poor people's attitudes towards rich people creating wealth and the the way I use it regarding victim-y, self-oppressed actors' attitudes toward success and empowerment. Interesting parallel, right? You should have seen the gal next to me stare. She thought I was nuts.

However, being in the drama business, I of course have added some physical flair and well-worn schmactiness to drive the point home with bold theatricality. I use my hand (left or right, sometimes both) to mouth the words much like a sock puppet. If you ever watched Sheri Lewis and her beloved friend, Lamb Chop, you know where I'm coming from on this. I talk back to myself, right in my ear, as quickly as the negative chatter escapes my lips or from someone around me and say, "Thanks for sharing!". Through acknowledgement of the critic in my head (and sometimes the balcony is full), I cancel it out so that it no longer swims around in my subconscious causing problems.

11 Amazing book. Buy it. There should be no such term as "starving artist." Yuck.

It really, really works! Try this or any version of the "cancel, cancel, cancel" theory so you can refocus that energy into something good. Consider it part of the work you do as an actor. Just like memorizing lines!

AUDITION MIND TOOL: PUPPET ATTACK

Now it's your turn. I hope you're not in the public library or on a bus because it could get hairy. No excuse though, you agreed to play for 200 pages and we're only half way there.

Be sure to do the physical action necessary—remember your nasty little ego is headed out the door to make room for some fun and I'll be holding the knob to kick it in the pants on the way out. If the little old lady sitting next to you stares, be sure to deliver a few lines *a la Saturday Night Live* directly to her. Are you ready? Doesn't matter. Do it anyway! Read the following script *out loud!* Here we go:

ARTIST: I'm not good enough. I suck.

HAND PUPPET (with "talking" hand close to ear): You're wrong. You do the work. Thanks for sharing!

ARTIST: I'll never make it.

HAND PUPPET (with "talking" hand close to ear): You know that's not true. Thanks for sharing!

ARTIST: I'm making a fool of myself.

HAND PUPPET (with "talking" hand close to ear): You're having fun. Thanks for sharing!

ARTIST: I can't do this. I'm not good enough

HAND PUPPET (with "talking" hand close to ear): You can do anything and you know it. Thanks for sharing!

ARTIST: I have to be responsible. How can I be responsible if I constantly play and have fun for a living?

HAND PUPPET: You're being responsible for yourself as an artist. Thanks for sharing!

ARTIST: I can't make enough money to have the life I want as an actor.

HAND PUPPET: You can make tons of money in tons of ways as an artist if you figure it out. Thanks for sharing!

ARTIST: I have to take every job.

HAND PUPPET: I don't see a gun pointed at your head telling you that you have to do anything. Thanks for sharing!

ARTIST: They want it this way.

HAND PUPPET: Who are they? That's a good one. Thanks for sharing!

ARTIST: There's not enough time to have a spouse, partner, lover, or family.

HAND PUPPET: Even better. Thanks for sharing!

ARTIST: My friends all have real jobs—I should, too.

HAND PUPPET: Thanks for sharing!

AUDITION FREEDOM

ARTIST: I can't own anything because I'll be out of town a lot.

HAND PUPPET: Thanks for sharing!

ARTIST: My parents don't approve of my lifestyle.

HAND PUPPET: Thanks for sharing!

ARTIST: I'll have to sacrifice my integrity to get ahead.

HAND PUPPET: Thanks for sharing!

ARTIST: There are no guarantees in this business.

HAND PUPPET: Thanks for sharing!

ARTIST: People won't love me for who I really am.

HAND PUPPET: Thanks for sharing!

ARTIST: I don't feel like an artist.

HAND PUPPET: Thanks for sharing!

ARTIST: I'm not creative.

HAND PUPPET: Thanks for sharing!

ARTIST: I'm afraid.

HAND PUPPET: Thanks for sharing!

ARTIST: I'm not attractive enough.

HAND PUPPET: Thanks for sharing!

VP BOYLE

ARTIST: I'm too old to start now.

HAND PUPPET: Thanks for sharing!

ARTIST: I could never live in a big city.

HAND PUPPET: Thanks for sharing!

ARTIST: I can't network like other people.

HAND PUPPET: Thanks for sharing!

ARTIST: I can't learn new things.

HAND PUPPET: Thanks for sharing!

(DO ALL OF THESE)

HAND PUPPET: Thanks for sharing!

HAND PUPPET: Thanks for sharing!

HAND PUPPET: Thanks for sharing!

HAND PUPPET: Thanks for sharing!

HAND PUPPET: Thanks for sharing!

HAND PUPPET: Thanks for sharing!

HAND PUPPET: Thanks for sharing!

HAND PUPPET: Thanks for sharing!

"No problem can stand the assault of sustained thinking." — Francois Marie Arouet Voltaire

SOLVE YOUR SHIT

Was there life before Google? I really can't remember or I've blocked it out.

I love—*absolutely love*—the fact that with some common sense and free time, I can learn pretty much anything in the world I need to know. Anything from soap making to mutual funds to color corrections for photography! It's all there. Granted, sometimes it takes some sifting through the deluge of dog doo-doo to find the information worth reviewing, but it's there or it leads me to sources where I can find it: books, organizations, individuals, movies, workshops/classes, the library.

With all this information available to us, it boggles the brain why folks stay totally stuck in the dark personal goo of things that are murdering their artistic selves.

Money problems? Addiction? Recovery? Health issues? Psychological support? Physical fitness? Holistic wellness? Spiritual enlightenment? Family crisis?

What about easy stuff like clearing your clutter, getting organized, being proactive with your career, finding out about new theatre opportunities?

There's nothing, absolutely nothing, you can't solve. It's true. You can solve everything in your world with dedicated thought and action. Sometimes the universe shows us a greater good than we ever

imagined when we're actually available for it and not trying to serve our inner child or victim. Really hear me on this! Information is your "please-get-me-unstuck" actor tool. It informs your brain and helps your heart. It can lead you to the thing you need most at the time you need it.

The thing about information is that it stimulates you and becomes part of the activity of moving forward and always learning. Learning is always active and opens doors to new possibilities, so the intention to learn new things naturally moves you forward. It enriches your life so that the acting part becomes less of the whole and simply an aspect of you and your choices at any time.

One of the best things I ever did for my theatre career and personal audition freedom *was to take a pottery class.*

I was walking across 19th Street one day—totally stressed out. Stressed by my survival job, stressed by a string of auditions that hadn't resulted in any immediate opportunities and stressed by all the daily wear-n-tear of the subway, winter weather, rude people on the street and a lack of sunlight.[12]

It was not a good day.

Then I turned to my left and saw the warm amber glow of a little pottery studio spilling light into the darkness of the street. Inside there were eight people sitting at their wheels, covered in mud, totally silent. I swear I must have looked like Julie Andrews in the opening scene of *Victor/Victoria* when she's standing outside a fancy restaurant, totally

12 It took me years to realize that I had a mild case of Seasonal Affective Disorder and that not getting enough sunlight each day during the winter months really did a number on my psyche and audition life. Someone suggested I look into SAD and a couple of hours of research on the Internet turned that all around! I discovered that by simply changing all of the light bulbs in my house to full spectrum light and spending my early mornings outside, the world was normal again. Suffer or seek information—it's a pretty easy choice!

starving and watching someone eat spaghetti through the window. I walked right in and signed up.

I had wanted to take a pottery class for as long as I could remember. The funny thing about it was that I couldn't come up with any solid reason why I hadn't. Time and money were totally solvable, so it wasn't that. If you had asked me to list five things that I had always wanted to learn and/or do, it would have been *in my top three*. Why did I wait?

The result was that I ended up in a pottery class for a year and a half and my theatrical endeavors suddenly gained great perspective. I credit that period for one of the biggest leaps I took forward in my acting craft and I didn't take a single acting class during that time!

Look at the reasons why...

1. I was doing something that fed my artistic self.

2. I was completing a goal I had wanted to do for years and learning something new.

3. I created dedicated time to get out of my head.

4. I was granting myself a creative outlet for renewal and joy.

5. I was in a new world full of people who share a common interest that wasn't completely dominated by conversation about headshots, resumes, shows, who got the latest gig and all the endless banter about what "they" are doing.

6. I was relishing my role as a novice in this very muddy, splashy, warm and artsy little community.

7. I was expanding my sense of self outside the world of theatre.

If you take a cognizant look at the areas of your life where you feel content and successful and take some committed action towards the areas that could use a little boost, you'll find that your acting career will progress quite well. It will become part of your world instead of being your entire world. I think that's extremely important in attaining audition freedom. You want to be able to walk in the room and walk out with the same sense of joy, ease and innate confidence that your personal safety is not depending on some expected result from those few minutes.

It is possible!

"Deep into that darkness peering, long I stood there, wondering, fearing, doubting, dreaming dreams no mortal ever dared to dream before." — Edgar Allen Poe

THE VORTEX OF DARKNESS

Life happens. There is a mode of thought that I find very useful—everything in the world and universe is simply information and the information *is neutral.* It's the energy we give it that creates more of the same whether we believe that to be good or evil. Basically, it's choice. Your choice. Do you choose positive thoughts or love the addiction to constant negativity? You should answer that question out of your personal experience and from the center of your being.

I'm not being Cinderella about the whole thing. I have my days where I feel like I'm at the royal ball and others when I have to dance around my Wicked Step Mother to see the light. I play much more at the ball these days and find I get many more invitations to life's party because of it. I'll leave any idea of a glass slipper out of it—I wear a men's size 13. Not pretty.

I think we have to entertain any personal work that can pull us out of the black hole of audition negativity that I fondly refer to in my workshops as The Vortex of Darkness. Just like the black holes in outer space, time actually stops there. While the rest of the world continues it's bizarre and frantic, yet elegant messy mixing, you stay stuck. Frozen in something that does not allow you to grow or move. Remember your imaginary diving exercise into your favorite body of water? Well, the vortex of darkness is the big winter freeze. Your life as a creative human being becomes suspended in some never-ending ice age with you, a solid specimen of artistic energy, trapped

in the glacial ice. If you find yourself stuck, light a fire inside your heart and get the hell out of there!

Guess what? Everyone feels stuck at some point. Or in the very least, feel like we are perplexed while we are creating imperceptible paradigm shifts and change.

Sometimes in our work as theatre people.

Sometimes in our life as humans.

Sometimes in our hopes and dreams as creative forces.

Let those moments of suspension inform you with ideas of what is next. It's like a diving board to the next level of freedom if you keep your learning mechanisms intact. Remember that humor is also your greatest tool to dig yourself out of those places and to keep moving. If you don't keep your mind, body and spirit moving, you inadvertently create a set of prickly handcuffs that leave you feeling trapped, covered in blood and wanting to spread your self-imposed prison experience to everyone around you just to get even. Do everyone a favor and find the ways to keep in the sunlight—especially for yourself.

"By the pricking of my thumbs, Something wicked this way comes." — Act 4, Scene 1 of Macbeth by William Shakespeare

YOUR EVIL BITCH

We all have a psychological entity that loves negativity. It feeds on fear and will do anything in its power to win—and keep you where it's all about you. It's our ego. The very thing that was created to instill fight or flight in the early days of our species now is the single most monumental force of struggle in our current consciousness.

It really sucks for actors.

More simply put, it's the dark side. The bad guy. The Booger Man[13] under your bed. The alien creature with smelly stuff dripping down your neck that will sever your head if you move. Yes, it can be that malicious, or appear to be a gentle lamb snuggling up to you for warmth when you are looking for love in all the wrong places.

Directors will pitch someone's picture and resume right off the table if anyone in the room mentions that an actor under consideration is a problem child, it's that dangerous to a cast. I've see it happen.

I think it's time to commit to a playful murder game. We're going to take down your evil bitch and it won't be pretty. This is your imaginary episode of *The Sopranos* where you star as the guest villain and you won't get caught when they find the obscured dead body floating at the bottom of the Hudson River—I hope.

13 I thought for years it was a monster with upper respiratory problems.

AUDITION MIND TOOL: DIAL M FOR MURDER

I want you to dream in color. Imagine a shadowy figure coming toward you and draw in every detail. Since you're committed to a life in theatre, this should be a breeze. The figure could look like some form of you or be more like an animal. It could be from a Disney-esque animated cartoon or your interpretation of *Dawn of the Dead*. You get to choose.

Fill in some very specific details for thirty seconds or so. How does it move, how does it prepare to attack, what sounds does it make, how does it breathe, how does it smell? Probably not like roses.

Let it get closer to you, but don't move a muscle.

Let it breathe all over you. Can you taste it's breath in your mouth? Does it burn your nostrils?

Let it threaten you. Taunt you. Tease you before it's impending attack.

Let it say anything you want it to say that can terrify you into silence. It can spew out your insecurities and fears all covered in smelly snot. Keep your eyes and ears open through it all, even when you want to spew.

Look at it and slowly smile through the slime. You have a secret. You know something it doesn't know. You have a truth that you unlocked through your magical quest to get to this place and time. You have found your destiny and you can't lose this battle no matter what the monster does. It is written in your heart and you've been granted a vision of the future.

AUDITION FREEDOM

When you see that the dark entity has suddenly stopped it's advance and it's spew of fearful ideas about you, I want you to slowly reach behind your back. There you will find your weapon.

It is a sword.

Remember who you are. You are a warrior of light and this is your destiny. There is no emotion—only the acceptance of what you know you must do.

Feel your hand grasp the handle. It has a warmth that travels through your body as you touch it. It is time to remember who you are. You have been here before and your sword feels like a trusted friend.

Remember, you are a creative warrior.

In one calm, smooth, clear and skillful stroke, you sweep the sword around you. Time slows down and you move in fluid slow motion. As the sword sweeps around your body, you notice the shine of the metal, the markings that have been your history. This sword is full of your courage, your battles, your lessons. It is your earned protection from all things. Watch as it easily meets the beast and moves through it. It severs the head, silent and swift, with no emotional attachment. You simply watch the activity and remain present to your task.

Watch as the head of the beast falls to the ground, never to claim your space again. As you watch it die, notice the details. Watch the remains dissipate into nothing but vapor that fades away into the universe.

There is now nothing but complete stillness.

Listen. Silence is your gentle reward.

Breathe in the clean air and enjoy the stillness.

As a warrior of light, you will have other battles. However, this battle is over and you have won. Let it be done and know that your vision of artistry and all the reasons you became an actor can now move forward with you as a victorious celebration of why you are here right now.

There are no accidents.

You are on the right path and you will do what you need to do at this moment in time.

"Once more the storm is howling, and half hid Under this cradle-hood and coverlid my child sleeps on." — *William Butler Yeats*

THE EYE OF THE STORM

I sometimes think the biggest obstacle and potential for disaster to any actor's audition is the waiting room. It's a level five twister heading right toward your creative house when you suddenly realize it has no basement.

I'm grew up in the Illinois Valley and we understood tornado weather and the freakish wake that one of those super scary—and super cool—windstorms could leave behind. When I was five or so, I remember being in the back yard one summer evening with my grandma looking at a very odd green sky. It was hot and muggy to point where it felt hard to breathe. What is the most interesting thing is that there was absolutely no sound. No crickets, no birds, nothing.

It suddenly got dark and chilly. The next thing I remember was having my arm yanked off as she picked me up and dragged me into the house, pushed me down the basement stairs just in time to hear a train in the distance. It didn't take very long. When we went upstairs a few minutes later, the plum tree I had loved to climb was laying on it's side ten feet from our front door but not a single window was broken. It looked like a giant hand had plucked it out of the ground like a weed and just set it down in the same place. A block away, however, one of our neighbors houses had been leveled. Fortunately, they were not home that day.

If you build a strong foundation, the storm won't threaten you as severely and you'll graduate to easier audition scenarios where it

becomes like old home week where you see friends or the same few folks again and again.

As actors, we are constantly striving to speak truth and find activities in our work. Do the same thing in the waiting room. Bring your journal, read a book, run lines, avoid the frenetic folks who think they know everything about what "they" want and just have a good time. Better yet, enroll an audition buddy to attend as many auditions as possible with you. Obviously, it helps if you are similar in type so that you can go to the same calls. Protect each other from the chaos of the waiting room storm and then go celebrate your experience that day by doing something you have pre-planned (and love) to do.

"Come to the edge", he said.
They said, "We are afraid".
"Come to the edge", he said. They came.
He pushed them...and they flew.
— Guillaume Apollinaire

AN ALCHEMIST'S TALE

Not every beast can be tamed or killed. Some of them are the closest people to you and your dreams that you could ever imagine. Parents, lovers, spouses, friends. Sometimes they just don't understand or can't get clear of their own personal agenda enough to truly support you. Not everyone, mind you. Sooner or later, these situations do show up for everyone in the arts and you have to navigate them. It's part of the ongoing process that keeps you in your commitment to theatre.

Oh, they may *claim* to support you. They may actually believe it, too. They might be wearing a cheerleading outfit with your name plastered all over it, but that doesn't mean that they are really creating space and support for you to grow and pursue your career. Whatever. You can't just pull out your imaginary sword and slice off their head unless you want to be doing your best version of *Seussical The Musical* in a blue striped suit with twenty convicted felons.

When information comes our way that we want to divert or transform, we have to put on our wizard robes from Hogwarts and practice a little audition alchemy.[14] You can spin iron into gold—it's all just energy. The mayhayana Buddhist practice around this idea in karmic terms is called tonglen. Literally, it is "taking and sending." It is used

14 If you haven't read *The Alchemist: A Fable About Following Your Dream* by Paulo Coelho, you must walk into the very next bookstore you come across and buy it. Non-negotiable.

as a meditation technique to take in all that is negative and harmful and breathe out compassion and transformational positive energy.

I like the idea of not putting a wall of energy up to battle the outside forces of negativity. It becomes useful because you are not spending your time making that negativity manifest as something tangible. Better to focus on what you want rather than what you don't want. Quantum physicists would agree that even saying something like "I won't let them get to me or make me second-guess myself" creates exactly the thing you're claiming you don't want! You will ultimately create constant opportunities to be bombarded by people *who get to you* **and** *make you second-guess yourself!* They certainly didn't teach that to us in any acting school or conservatory program. They also didn't prepare us for the life force that we would have to dedicate to auditioning and staying healthy about the process in order to succeed.

Let me be very clear that by success, I mean doing what you choose to do with joy and freedom so that you create the best possible platform for results. Try transforming negative energy instead of blocking it for your next three auditions and see what happens. It's pure magic that you create and is nothing but energy, thought and commitment to your audition wellness.

If you want another example of this theory, I encourage you to watch a brilliant film set during the Holocaust called *La Vita é Bella (Life is Beautiful)* starring Roberto Benigni. I'm a big fan of films that champion the human spirit and this is one of the best. They can change you forever and bring new appreciation to the art and freedom you already enjoy in certain areas of your life.

In the film, Benigni plays an Italian Jew who must rely on his incredible imagination and sense of wonder to create a way for his son to survive their ordeal in a Nazi concentration camp. Talk about transforming a life experience! When you stop to consider the trials and tribulations

of millions of people living in our contemporary world who would sever a limb to have running water and not think twice about the choice, how can you seriously choose to be anything but happy every time you get to do a monologue, sing a song, kick your leg over your head or change clothes just to play a role.

We play for a living and we are *very, very lucky* to be able to pursue this art form. Theatre is a gift. Don't forget it now or when you're a star, today or twenty years from now, or I'll hunt you down and wack you on the head with this book just to wake you up a little.

I swear I will and I'm a man of my word.

 ## AUDITION MIND TOOL: SPINNING IRON INTO GOLD

Let's try a very scaled down, easy version of this transformational meditation technique. Take five simple, slow breaths to relax and center yourself before you begin.

Now, imagine that you are standing in the waiting room of a huge audition where the energy coming at you doesn't feel quite right. Pretend that the uncomfortable or negative energy (words or non-physical behavior, including observation of others from a distance) is dark smoke. Inhale the dark smoke into your lungs and imagine it going to your heart.

Because you are an artist with a big and generous heart, you have no trouble taking all of that energy in and converting it into white pearlescent mist that is full of calm, joyful light. Send that out of your body with the exhale into the room and to all of its inhabitants. Continue for ten breaths and then relax. It may seem hard at first, but ultimately it will leave you feeling refreshed!

Like the alchemist who spins iron into gold, you can spin harmful energy into healing energy for yourself and those around you. It can be a tool for you to use in the waiting room or when the closest people around you are doing their best to divert you from your chosen path. Even though their non-supportive energy is based in their perception of support and love, only you can decide what is right for you. Using some form of this transformational technique of breathing in negativity and breathing out healing energy can change your audition life forever. However you decide to make it your own, you can create audition freedom not just for yourself, but for others.

There is no limit or fatigue to this process. It should energize you. The more you do it, the more energy and stamina you should have to go further.

This audition alchemy can create powerful energy shifts in how people respond to you at every level. I guarantee that this technique alone will lead to audition experiences and relationships that support results.

PART FOUR

LIVE
IN THE
WONKY PLACE!

VP BOYLE

"Art teaches nothing, except the significance of life." — Henry Miller

ADVANCED AUDITION TECHNIQUES... AN INTRODUCTION TO BEING HUMAN AGAIN

I've spent thousands of hours in rehearsal studios all over New York City coaching Broadway actors. The next session of this book will be dedicated to some of my different ideas about taking your work to the next level. I define the work more as playtime, but you can bring whatever training and background to the plate as you see fit. I have no need to reference or embrace any particular acting method in my goal to help you create audition freedom. They all have value and much like individual coaches, teachers and mentors, the right one will serve the right person at the right time. There are no rules!

What I know to be true based on results is that bringing the human element into the room after you have done all the technical work and preparation for whatever you are auditioning for is the key to success. Read the rule books, learn the techniques, take courses of study, find the material that serves you and keep doing that very practical and very necessary work. *It will never end.* Here's a little secret I'll share with you: It only goes so far and then you have to learn how to be a real person again in your work.

The weather forecaster in your brain may be issuing small craft warnings right now. "What do you mean? I'm a real person! Of course, I bring that into the room! Who the <bleep> are you to imply I'm not doing that kind of work! I do the work."

I make no assumptions, but I have become an expert on teaching authentic audition freedom. The entire casting experience is actually

interactive. It's a dialogue whether you realize it or not and that is a key element in the not-so-scientific equation. You have to raise your awareness about all of the information that is being offered, interpreted and deciphered when you're not performing. That is the practical element that has the most weight in the final casting decision. By the time we've distilled all the potential actors down to that final decision point, *everyone is good enough.* Everyone has something to offer to the project, but we only get to choose one actor.

Please don't get me wrong—talent is a substantial part of the final decision. However, it's not all of it. Many Broadway casting directors and directors would even go so far as to indicate that once we get to the final options, it's the least important aspect because everyone has talent, is the right type on some level and will serve the project. In the end, it all comes down to a decision based on instincts and trust. And we tend to trust our instincts about authentic people.

We *love* people who aren't hiding behind desperation. We *love* people who aren't hiding behind a slick facade. We *really love* people who aren't hiding behind a barrage of red flags like self-deprecation, lack of self-esteem, nervousness and fear. We want the people who seem totally comfortable in their own skin and aren't afraid to have fun. We want the people who are actually sharing the experience with us in an interactive way. They see us. They hear us. They play with us. Then they leave.

When people like that walk out the door, the room will buzz with excitement even if everyone knows that person is wrong for the project at hand. Notes, mental and physical, will be made that this person is someone we want to hang out with. I guarantee you that when that occurs, you have just sent a ripple of energy into the world, much like the ripple on a huge pond made by a single drop of rain, that will affect many possible creative outcomes in your future. You will end up working, in some artistic way, with someone in that room, or with someone connected to someone in that room.

AUDITION FREEDOM

It's the law of the theatrical universe.

I invite you to consider being yourself at all times in the casting circumstance. You'll ultimately win. You'll create great experiences for yourself and those around you. You'll feel good about your work. You'll just feel good, period. If that isn't a cut-and-dry reason to do whatever it takes to trust yourself and feel good about everything you do in the audition room, I don't know what is.

Pay attention! Who knows what you might learn at every corner in your personal and theatrical life that could inform and expand your audition experience. That is your life as an artist, whether you to stick to spending that time in dark and crowded hallways mastering every Velcro costume change on the planet or whether you make urban art with origami peanut butter sandwiches.

Appreciate yourself and choose to feel good. Not just good, *choose to feel great*! That is the work. That is the road to being authentic. That is the world's expectation of your commitment to storytelling. And we, the world, will support it on every level if you give us the chance.

Please, please, please give us the chance!

I'm going to help you do exactly that with ten practical ideas you can apply to your audition life so that you can move forward with your work. I will give you my little workshop tools that I've developed, stolen or adapted to my way of thinking about audition technique over the years. Although my approach is not for everyone, the following ten fundamental applications will speak in their own way to anyone.

Even you.

"Do or do not. There is no try." — *Yoda*

TECHNIQUE 1: IF YOU WALK OUT THE DOOR AND GET HIT BY A BUS

Today is the perfect day to tackle this chapter as I sit in my apartment, enjoying a rainy autumn drizzle outside my windows. I love the feel of blustery weather—so much so that I never carry an umbrella. I live near Fort Tryon Park in New York City with a full view of a rocky hill and lower park area. Rainy days for me can be a crunchy blend of coffee, sage incense, quiet time and uninterrupted writing moments. Lately, I've been listening to a soundtrack of the Humpback Whale and sometimes find myself laughing at the joy in their non-verbal banter. A one word summary of all this would be: *appreciation*.

I love my life. Theatre is what I do. It's a shiny facet of who I am and the choices I make, but it is integrated into my life so that it informs my days, not dictate them. My theatrical mantra of late is to do what I want to do when I want to do it with regards to theatre and not let the ideas of boundaries muddy my festive dramatic coat of many colors.

I spend my days coaching my students, expanding perceptions about my work as a performer/director and continuing to write everything from books to musicals. The icing on the cake for me would be for everyone reading this book to realize that we only have today and to *truly get it.* Oh, I know we hear it. I know it's the cool neo-spiritual thing to say, but I also know I'm constantly trying to figure out what the heck it really means.

I get closer to the truth of it every time I give myself permission not to have any expertise at life. Every once and a while, I'll find myself

naked and shivering, sliding down the water slide of daily indifference into a frozen wave pool only to hit the ice so hard that I knock myself back into consciousness. So be it—no one is perfect. I just pick myself up and start to recreate my world again by wrapping myself in the blanket of warmth called *appreciation*.

It can really bring your work and your humanity to a new level. If you want a kick in the pants for your career, realize that every time you walk into the room to audition it may be the last time you ever get to do what you love to do. Appreciate the experience. Appreciate the people in the room. Appreciate the friends you make along the way. Appreciate your process. *Appreciate yourself.* No matter what age you are and where you are in your acting journey, the fact remains that we only get a micro portion of an itsy-bitsy nanosecond in the big picture of life. In the end, why should we stress about stupid shit? We do shows. I repeat: *We do shows.* If the pure simplicity of that doesn't hit home, I'll say it again. *We do shows.*

I give a powerful note very often to actors in my workshops and it is simply this: You've been granted a vision. You somehow know that when you walk out that door tonight, you will be hit by a speeding bus. There is no negotiation, it just is. You're not anxious or afraid because you know it only means the end of your time in this reality, not the end of your eternal experience. So now that you know this special information, you better make this moment really count. Relish everything about the story you are going to share right now with the folks in front of you since it will be your last one on this planet.

I can't find words to express the quality of some of the performances and transformations that have occurred when I give that note! It's breathtaking and powerful. It's a call to arms. It's a clarion message that you only have now and there is no time to waste. Use it! Enjoy the work and the moments you have to tell your stories. Learn the art of appreciation for what we do as theatre people and share it with everyone in the "now."

AUDITION MIND TOOL: EVERYTHING. EVERYONE. EVERYWHERE. ENDS.

I stopped dead in my tracks (pun intended) when I saw the promotional poster for the last season of HBO's *Six Feet Under*. It read: *Everything. Everyone. Everywhere. Ends.* What I realized as I brewed on the idea and image of a car traveling off into the distant light, was that the implied conclusion to this was: Everything. Everyone. Everywhere. Ends. As We Know It Right Now.

Nothing really ends, but our time is limited and the not-so-random intersections we have with others infuse the ride with real connections. We get stuck together at the top of the Ferris Wheel in a midnight sky on a warm summer night with someone we love hoping to never come back down to earth.

This next Audition Mind Tool should bring you pure joy and feel wonderful. I want you to celebrate and remember someone who has been a wonderful part of your life experience *but who is no longer on our planet.* Remember a specific time with them that was shared only by the two of you and fill in the details. Where were you? What were you doing? What were both of you talking or not talking about? How old were you? What was he wearing? How did she smell? Enjoy all the sensory details that you can recall and imagine any details that you don't remember. Enjoy filling in the gaps with anything that gives you pleasure.

Clearly address him or her in the way that you would based on your relationship and invite them to listen to you for a moment. Tell them how much of a difference they made and how much you appreciate the time you had together. Allow a moment of silence to just feel what it is like being with him or her again and having that the person share

your space. If it's appropriate, hold them or touch them in your mind in any way you feel comfortable with and just be with them.

When you are complete, wave them away with joy and appreciation for the visit. They will always be available to you whenever you need them. Just ask. Just invite. Just appreciate. When you are done with this exercise, tuck this book away and do not return to it for the rest of the day. Keep your mind on the quiet side without doing anything except appreciating everything around you.

"Make voyages. Attempt them. There is nothing else." — Tennessee Williams

TECHNIQUE 2: LOVE, LOVE, LOVE YOUR MATERIAL

Did you honestly realize how much you have to love your material? I'm not talking puppy love. I'm not talking about a too-many-beers-one-night-stand kinda love. I'm talking about the kind of love that involves words like "until the day I die." I bet you never thought about that when it came to choosing monologues or songs. Take one of my workshops someday and you'll get clear on it mighty quick.

You will never be truly and totally free in audition-land until you are doing material that speaks from your soul. Every monologue or song that you choose to showcase your skills must be a gift to yourself every time you get to do it—otherwise, throw it out. You really can't settle in this aspect of your work. I know that as actors, the expectations to cover a ton of bases is getting bigger all the time. Great! You now have the opportunity to find or stretch a little outside of your comfort zone to find material that can accomplish whatever you need to do and still fit you like a well-worn coat.

I teach an entire workshop for Broadway level musical theatre actors about building their audition books. Sure, I toss out tons of song ideas for them to explore based on what I see, but in the end it comes down to songs and stories that thrill them on every level—emotionally, mentally, physically and spiritually. No matter what you are told, someone else cannot and should not be the deciding factor for the text you choose to work with in your auditions. They ain't the ones doing it!

I struggled for years with finding a good standard Broadway ballad. I love the contemporary stuff, so whenever I was asked to sing from

the classic era of Broadway, I sang songs that I was told to sing based on my physical and vocal type. I spent years singing *On the Street Where You Live* by Lerner and Loewe and then moved on to *Where or When* by Rodgers and Hart because someone told me they would be a good songs for me to sing. These are great songs, but they didn't ultimately speak to me even though I sang them for years! Finally, a trusted casting director friend of mine took me aside in the hall after an audition and said, "You really don't like those songs, do you?" I thought for a second and responded, "You're right. I hate those songs!"

What an epiphany. Better late than never, I guess. I searched high and low for the next six months for something I would love, love, love. I finally hit pay dirt when I came across *My Romance* (also by Rodgers and Hart) and it spoke to every molecule of my body.

After that, whenever I walked into the room and someone asked me to sing a standard ballad, a little voice in my head yelled, "Yippee! I get to do it again!" and life could never be better. It is always pure rapture. I feel that way about ALL of my monologues and songs. Interestingly, I started to love auditioning because I get a chance to do some of them every time I walk into the room. I've won before I've even begun and it doesn't even matter what the creative team thinks about my material.

Whatever stage of the game you are at right now, dedicate some serious quality time to looking at your material. Start with the question, "Do I love it, love it, love it?" Better yet, ask yourself "Does this make me a better person everytime I get the chance to do it?" If you even have to think for a microsecond about the answer or it's in any way less than the urge to jump up and down to celebrate the word "yes," then plan on replacing it as soon as possible. You have far too much to do to be working on or performing things you don't cherish.

Get a move on it!

*"Let your soul stand cool and composed
before a million universes."*
— Walt Whitman

TECHNIQUE 3: BREATHE

The golden key. The source of your life, your center, your body and your focus all comes down to the thing you do naturally because there is no other option. Breathing.

Notice your breath.

It can solve everything that comes at you from inside or outside, but you have to allow it to work properly. You have to create an awareness of its instrumental participation in your "moment-ness."

Notice your breath.

In and out, in and out, in and out. When our mind creates physiological responses such as adrenalin rushes or other chemical reactions in our body, we have no choice but to navigate them. It stands to reason that how we feel and think about things naturally can affect or be affected by our breath.

Notice your breath.

You have a responsibility as an actor to make breathwork a substantial part of your training regimen whether you sing or not. Vocal projection and breathwork is usually addressed somewhere along the line in any disciplined sport and theatre is no different. What often gets passed up is the awareness of your breath before, during and after auditions.

AUDITION FREEDOM

Notice your breath.

What do you notice about your breath? Do you like to breathe deeply or is your breath shallow and in the upper part of your chest? Is it fast or slow? Do you have panic breaths after a short period of sustained, even breathing?

Notice your breath.

Do you find yourself stopping your breath at times? Do you manipulate the speed of your breath and when? Do you sometimes feel like you can't get enough air?

Notice your breath.

If you do any sort of exercise practice, you know about how important your cardiovascular health is to your ability to sustain periods of high energy. Auditions take enormous amounts of energy on every level: physical, emotional, spiritual and mental. Even staying centered, remaining calm and being focused require titanic amounts of energy.

Notice your breath.

An important aspect of finding audition freedom is the ability to be present for your journey. It's the ability to tell stories time and time again that are completely clear and mapped out on one level of yoru consciousness while allowing you to experience them for the first time on another level. The bridge to connect the space of that creative chasm is your breath.

Notice your breath.

You basically have to stand on both sides of the Grand Canyon and walk towards yourself in the journey of your story. On one side, stands

the actor who has made the crossing many, many times. This aspect of you, the storyteller, hopefully knows every detail and crevice of the trip and is prepared with the tools they need to navigate any potential storm or obstacle. This is the actor who has great faith that they will reach the other side once again, unscathed.

Notice your breath.

On the other side, facing this expert journeyman stands the novice. A human spirit who has never seen this particular crossing, this ledge, this unknown precipice and who is experiencing everything for the first time. They didn't expect to have to face this journey and yet realize in this very moment that there is no other option but to attempt the crossing. They are looking you directly in the eyes from the other side.

Notice your breath.

You are an actor who must live in two realities that will always exist at the same time. That is the way it works. It is your chosen paradox. You can be present, but you also know that in some part of your body, you remember this particular adventure because you have chosen it.

It is your story. It must also breathe.

AUDITION MIND TOOL: ONE MINUTE TO BREATHE

This one is easy and yet may be the most powerfully challenging to you.

Wherever you are right at this moment, pay attention to nothing else except your breath. How and where it manifests in your body. How it feels going in. How it feels going out. The temperature. The texture. The feeling of it as it enters you through your nose and mouth.

Just notice your breath for one complete minute.

Breathe.

"Every heart that has beat strong and cheerfully has left a hopeful impulse behind it in the world, and bettered the tradition of mankind." — Robert Louis Stevenson

TECHNIQUE 4: LIVE IN YOUR BODY – ALL OF IT

Of my top ten audition techniques, this is by far the hardest to communicate on paper. You have to live in your body. Not certain parts of it—all of it. You cannot sever the energetic connection and awareness of your limbs, hands, fingers, whatever. You can't under any circumstance go all glazy on us behind your eyes or lock up. Why? Because you lose the very parts of your instrument that you need to be an actor.

Your body is made up of cells that are in turn made up of smaller and smaller and smaller particles that are in turn made up of energy. You are a brilliant mass of vibrational energy wrapped around creative consciousness. You have to use all of it to be a great actor.

If you don't believe me, then watch everything that Tom Hanks has ever done and get back to me. You'll get it. Watch Michael Phelps swim. You'll get it. Find interviews and video clips of Lance Armstrong when he races. You'll get it. See Madonna in concert and get back to me. You'll get it. Play with any child under the age of five in a park. You'll get it. Watch a bride and groom dance at their wedding. You'll get it.

Read books. Do yoga. Get acupuncture. Study Reiki or Reflexology. Swim naked in the ocean. Have tantric sex. Do whatever it takes to

reconnect with every string of vibrational energy in your body so that you can play your physical instrument at will in the audition room. You absolutely must do it and there are many different and totally wonderful paths to that goal. Additionally, they will improve your immune system, your mental health and your overall wellness.

AUDITION MIND TOOL: X-RAY VISION

You get to be Superman for a minute. You can be Superwoman, too. I'm not being sexist but the only other DC Comics characters that officially had x-ray vision were Supergirl and Ultraboy and both of those names will dig my hole even deeper with some folks. Cut me some slack.

I want you to "energize" your entire body, bit by bit, starting with your toes and working your way up to the top of your head. This actually gets interesting because I want you to imagine that you are sending warmth and beams of light from your eyes to every section of your body and then becoming aware of these beams.

Don't move on to another part of your body until you feel like that part of your body has "woken up" and feels fully alive. If you get to the top of your head (and yes, you can imagine seeing backwards—it's a brain exercise) to realize some part of your body has gone "back to sleep" then go back and stare some warmth/light into that part again.

Do this for one minute.

When you get really good at it, you'll be able to do it in ten seconds or less and feel totally buzzy. You'll also start to notice when stuff is going on in different parts of your body that may require some attention. I'll leave it at that for you to explore further.

"The more I give myself permission to live in the moment and enjoy it without feeling guilty or judgmental about any other time, the better I feel about the quality of my work." — Wayne Dyer

TECHNIQUE 5: BE AWARE OF A 360º WORLD

I'm not sure where or when everyone got taught that they should walk into a room, stand on an imaginary "X" in the middle of the room, stare at some dot on the back wall with their arms locked at their side and pretend that this constitutes authentic human behavior. If you did that to me on the street, I'd call 911 and run.

Seriously! I understand better than most the importance of stillness and specificity in storytelling, but have you ever gone to see a play or musical where the characters did that?

Hell, no.

Theatre has gotten quite filmic. The acting style and advances in audio technology allow us to be more like we are in our daily lives rather than just strident, booming voices trying to hit the last row of the mezzanine. Those are days gone by and those rules no longer apply.

Granted, theatre is usually a proscenium viewpoint for the audience, but actors are expected to live in any given "space" as if it had four walls and if you want to take your audition experience further, learn how to become aware of a world that is all around you. I'm referring to the room in its reality and the world you create for your story. They have to be rich and you have full permission (mine!) to use them. If you have come out of any classroom, program or situation that has

boxed you into some stiff idea of what an audition should be, *start over*.

Start with gentle awareness of the world that lives beside you and behind you, above you and beyond the scope of what you actually see. Notice the temperature of a room, where the light comes from, how the air smells, etc. You'll find new information for your story and you'll show up like what we really need to cast.

A human.

AUDITION MIND TOOL:
SNOW GLOBE LIVING

The kitch-fest around the holidays provides an inspirational visual for my next cerebral exchange with you. You're a snowman or snowlady trapped in a giant snow globe and I get to shake you up for my instant gratification.

Imagine this enclosed world that you live in is about ten feet in all directions with thousands of cheap pieces of plastic floating all around you. You can try to look at all of them individually, but it's impossible. However, if you really open up your mind to the flow of the snow, you can sense it everywhere. All of it.

This is a great way to approach the audition room. If you really dig deep and create rich environments to serve your scene, you will suddenly find grounding and centering that goes beyond anything you ever imagined.

And 3-D physical awareness and sensitivity to your environment is super cool!

Really spend the next minute becoming aware of the environment in your present circumstance as you are reading this. Without looking, put your focus on the area above your head. Move your focus to the area behind you that is not in your peripheral vision. What about below you? Are you aware of the earth below you?

Now here's the zinger—become aware of all of it and live in that awareness for as long as you can. How does it feel? When you feel comfortable, expand the diameter of the space that you perceive around you by five more feet. Can you expand it to ten feet on all sides? Twenty feet? Give it a try!

Check in with this exercise whenever you can throughout your daily routine and then start to work with it when you are preparing text (sides, monologues, songs) and see how it affects your work. You'll feel present, centered and much less obligated to do things physically that have no meaning.

"Why not go out on a limb? That is where the fruit is." — Will Rogers

TECHNIQUE 6: PLAY BIG

Don't you love that classic tried-n-true poker scene in movies where all the money is on the table, one card in hand, and someone draws three cards to end up with four aces. Everything from westerns to modern dramedies will recycle it, but you can't help but enjoy the final play! Yes, I know it's extraordinary, but it's drama for crying out loud and it's tons of fun. We always live in the extraordinary—we just call it theatre.

You can play it safe and truck along, or you can play a high-risk game. Either one is totally acceptable and may work for different people. I know a slew of Broadway gypsies who go from show to show and love doing chorus work. I also know some brilliant actors that work less, but have won every award in the book because they have waited for the right project to come along and it fit them like a glove. No matter how great you are and how far along in the theatre industry you've traveled, the fact remains that you will spend more preparation and training on the audition part than on the performing part. From my point of view, that seems to make the preparation and training that you do for auditions one of your biggest artistic outlets when it comes to your work. Great! Would you choose to play it safe once you had the job and were creating a role in front of 2000 people, some of which were Tony voters? It's something to think about when you walk into the room.

If as artists, we think the primary task is looking for work—then what the hell, as artists, is actually our work?

Sometimes you'll suck big. Sometimes you'll win big. Sometimes they may go hand in hand. Sometimes not. No matter what, you'll always be playing big and that will be respected in the long haul.

I have some total audition doozies that I wear in my feather cap of casting disasters. Wicked capers that now have become part of my own personal folklore and make for great entertainment when I drag one of those hoary chestnuts out of the memory trunk. I also have shared the stage with some really great talent because I could hold my own and had proved it from the very moment I walked into the room.

Suck big. Win bigger. You'll have some really great clips on YouTube when you hit the top.

"Dost thou think because thou art virtuous, there shall be no more cakes and ale?" — *William Shakespeare*

TECHNIQUE 7: TRUST THE STICKY STUFF

Instincts are good, but no matter what technique you love to use in your acting work, I guarantee you that you will gravitate towards something expected that lives within your safety zone more often than not. That's why we have safety zones! I support them on every level as something to notice, appreciate and then bust out of at every chance like a bungee jumper on crack, well—not crack.

When it comes to the stories that you choose to develop, interpret and tell, you have to make them breathe with your personal experience. That's a no-brainer, but making them interesting, dramatic and logical in front of total strangers is where the catch occurs. As you are making your way towards audition freedom in the room and towards greater artistry in your acting work, I want you to do something very simple.

Skip the first three choices. The easy, pat, clichéd choices like dreamy love, anger or some idea about being naive. That's it. It's really that easy to discover things you normally wouldn't find in the text (music or monologue) and the natural course of those events will lead to exponential ways of discovering new things in your work. It also helps to get yourself past the monotonously cheap actor places like anger, dreamy love and twitchy neurosis that is founded in nothing-ness. You can try playing the opposite of what you are saying or playing absolutely nothing at all, but if you skip the first three choices that you gravitate towards, you will most likely find yourself in the yummy human goo that we find interesting behind the table. Sticky, rich and full of fascinating human behavior that can ultimately help us with the show if it's not quite on the page. It will get you in the casting mix.

"If you reveal your secrets to the wind, you should not blame the wind for revealing them to the trees."
— Kahlil Gibran

TECHNIQUE 8: KEEP A SECRET

A very talented director friend of mine and I had cheap margaritas and burnt Tator Tots one night while waxing philosophic about the state of theatre. We hashed this conversation amidst vintage trash décor complete with black velvet Elvis paintings in a trailer park theme bar.

My director friend is obsessed with internet video clips. I must admit, it's a phenomenon and quite unbelievable when it comes to what you can find on the world wide web—including some clips from shows I've been a part of that really should rest undisturbed. He had been researching Judy Garland clips for a project and had an interesting theory about something in her storytelling that made her a bona fide star. She was brilliant at exposing herself and her stories in a way that seemed like she was saying, "I really shouldn't tell you this, but…"

It's true! Although I think keeping secrets with your loved ones in real life leads to manipulation and a slew of personal problems, I think it's quite useful in audition technique because it creates intrigue. If you own some bit of your story as if there is something we don't and won't ever know, we can't help but be that more interested in finding out. Find ways to infuse your work and your story with a little tidbit that will ultimately not be revealed. Reveal the rest and keep a little bit for yourself!

There are two benefits to your audition experience from this morsel of craft:

AUDITION FREEDOM

1. You're way more interesting than most of the people that walk into the room.

2. You subliminally have set yourself up to not to feel completely depleted by giving absolutely too much to the creative team.

You can bring yourself into the room, tell great stories, build a rapport so we decide we want to work with you. You can also keep a little something for yourself so you walk out with your chin held high.

I find that over time, you will reinforce this in your work so that you will actually feel stronger in your faith to show authentic vulnerability without getting hurt. It's the equivalent of training to do a marathon. No one in his or her right mind and body sets off on a twenty-five mile race without training first. You start off in small increments so that you build up to that very long distance and your confidence in going further each time is supported by the previous experience. You learn over time that you will cross the finish line unscathed. You trust your mind, body and spirit so that you can travel longer, more treacherous distances. You're probably very tired, but that's part of the rewarding burn.

Nothing is different in acting. When you work your ass off and go the distance, you'll feel an awesome buzz from being in the zone.

"There is a point at which everything becomes simple and there is no longer any question of choice, because all you have staked will be lost if you look back. Life's point of no return."
— Dag Hammarskjold

TECHNIQUE 9: KNOW THE MOMENT YOU CAN NEVER GO BACK

I don't want you to just tell me that you already know the moment when you can never go back. I want to *witness your discovery* of that moment. If I get to share that kind of ride with an actor, I always remember them and usually call them back.

Go through every single piece of text you ever do, song or monologue or side, and find a spot when you can never go back to the person who set out in this moment in the first place. Then make sure as you are building your story that you hit that mark and find something new in it every time.

There is the work in a nutshell.

I don't pay big bucks to go the theatre and have characters tell me what they've figured out. I want to see them work their shit out in front of me right on stage while every curve ball in the book is hurling at them at 90 miles per hour. If I'm the actor getting pelted dramatically, you sure as heck will see me grab a bat and start swinging, do some spur-of-the-moment moves to sidestep them or feel the pain. All are acceptable choice since I'm not telling you how it went. I'm living it. When it's all done, I hope I've discovered something I didn't know

when I start—even if it means I won't play baseball ever again until the next performance.

Now, I realize you can't really apply this to a two-line read for *Law & Order* when you're playing a bartender. That's a different sort of audition beast and it requires nothing more than for you to be totally yourself and hope that's what they think the bartender should look and sound like. I'm talking about theatre. I'm talking about walking into the room and being asked for a monologue and you knocking Tony Kushner's text out of the park in one solid hit because you did the work. I'm talking about singing Sondheim's *Being Alive* and stunning everyone in the room into utter silence at the power of your discovery on the last two words that you've already repeated twenty times for twenty different reasons.

You are making a commitment to theatre. You are making a commitment to acting. You are making a commitment to be a storyteller for our time. Tell really great stories.

When you do, you'll never go back to before.

"The only thing that makes life possible is permanent, intolerable uncertainty; not knowing what comes next."
— *Ursula K. LeGuin*

TECHNIQUE 10: LIVE IN THE WONKY PLACE

My favorite teaching quote! Actors across New York City have heard my soothing voice gently whispering, "Live in the wonky place!" on many occasions. If you believe the soothing part after reading this far, I'll be sure to sell you land in Canada. I'm usually hopping around, jumping on chairs and screaming at the top of my lungs (nicely, of course) for them not to run screaming out of brilliant work that they've just achieved because of crazy things like uncertainty, fear, truth and all the good stuff we spend thousands of dollars on to discover as actors. You're going to get out alive, I promise!

Living in the wonky place is…

1. Trying to understand what just happened.

2. Having no clue how you got here.

3. Having no clue where you are going.

4. Realizing you can never go back to before.

5. Seeing someone in a different light right in front of you for the first time.

6. Setting out to do something and finding something in the process that you never planned on finding.

7. Transforming others through your courage to move forward no matter the price.

8. Not rushing anything.

9. Celebrating your journey and all it's detail.

10. Forgetting who you were.

11. Remembering who you are.

12. Knowing you'll be OK.

13. Wrapping your mind around what's next.

14. Getting away from your ego.

15. Taking it all in before you stop to think about it.

16. Learning to love being lost so you can relish finding your way.

17. Doing nothing when every molecule in your body says otherwise.

18. Loving someone when you'd rather not.

19. Finding love from out of the blue.

20. Nothing more or less than just…being.

AUDITION MIND TOOL: HARDCORE APPRECIATION SPEW

One way to open yourself up to creating more fulfilling work and finding freedom in all of your creative endeavors, including auditions, is to start in a place of appreciating what you already have right now. This may be harder than you think, but get ready.

Find a way to time yourself—you'll need a full sixty seconds and no less. Sometimes I'll do this in my workshops and make someone receive compliments for a full minute from everyone in the room and you should see the trickle of sweat drip down their forehead as they acknowledge each one.

Are you ready? Appreciate and acknowledge yourself for one full minute, out loud. The way I see it, you should be able to get in at least 30 appreciations if you don't wuss out. Give it your best shot! You can say anything you want as long as it starts with:

I appreciate and acknowledge myself for...

GO!

PART FIVE

EXCUSE ME, YOUR LIFE IS WAITING!

VP BOYLE

*"Old friends pass away, new friends
appear. It is just like the days. An old
day passes, a new day arrives. The
important thing is to make it meaningful:
a meaningful friend or a meaningful day. "*
— The Dalai Lama

WHOSE LIFE IS IT, ANYWAY?

On top of everything we yearn for in life—success, prosperity, loving relationships, creative outlets, family, spiritual growth and a thousand more things only you can (and do) dream of having, we have to really figure out happiness.

Happiness can involve theatre, but it's a big idea that involves all the areas of your life. Not just one. Why is this so tough for actors?

I think the part of our lives we devote to theatre can be filled with happiness if we set ourselves up to win in those other parts of our lives. You might be the best actor on the planet, but it won't matter at all if you don't appreciate and relish your life. What fun is the lead role in a show if your marriage is on the rocks? Who cares if you are talented if you are so broke that every time you walk into the room you come off as needy and desperate? Why would you want to go out on tour if you have health or mental issues that require you to remain under strict medical supervision at home?

I use extreme hypothetical examples because life is, well—extreme. The turbulence is just flow, actually, and can provide the information you need to make choices based on your desires. Welcome to creation! I always tell my students not to be total goobers about theatre stuff because life comes first. I mean it. Life comes first! If you are truly committed to your life in theatre and true wellness in the

auditions that are a part of that commitment, you'll find that you need to keep your priorities straight. What I'm really hinting at is the need to integrate and create awareness on all aspects of your life so that you are continually learning and growing *as a human*. It makes you a much better actor. Maybe not more talented, but more castable in the end because you're not some freaky, obsessed, self-absorbed mess when you walk through the door.

Actors (artists in general) come from a point of lack. Why is the term "struggling actor" or "starving artist" so prevalent in pop culture. Blech! Lack of power, lack of control, lack of prosperity, lack of abundance, lack of love, etc. More accurately, it's a *perception of lack*. You want to know why?

Most actors think that happiness will be handed to them with the next role, the next show, the next bigger paycheck. Think again! That's Pulitzer Prize level fiction. You're life is your life and no one gives a hoot about your happiness (except maybe a few close friends, family or loved ones). Certainly no one behind the casting table or on the creative team because *it's just not their job.*

I had an epiphany (we'll call it Epiphany Part One) when I held my best friend's newborn child, Drew, and he fell asleep in my arms. I've got what my friends now call the "magic belly" because any infant that comes in contact with it falls instantly asleep. Just one of my natural gifts! As my friend got some well-needed sleep, I just sat in quiet awe looking at this sleeping infant in my arms and realizing how much energy I waste on stupid shit. My life changed in that very moment so much so that I decided to take a year off from all things theatrical to be Drew's nanny and take a break from theatre. It was one of the best things I ever did! I came back to "the biz" when I was good and ready to find nothing had changed. Most people thought I was out of town on a job. Hah! They were right. Meanwhile, I got a life experience that I would never have the opportunity to have again for the rest of my life.

Epiphany Part Two: I was contracted to cover eight roles in a very big Broadway show that was going out on tour and failed to get an official contract rider to attend my *other* best friend's wedding. We were teching the show at the Shubert Theatre in New Haven, Connecticut, and my Production Stage Manager was less than amiable about my wanting two days off to go to the wedding since it wasn't "family". It was more "family" than most of my family! Out of integrity, I told the truth when I could have called out sick and ended up being told that I absolutely, imperatively, must be there because of the complexity of the show. I acquiesced and ended up spending ten minutes on the stage standing in work lights while the three principles stayed home that day.

Ten minutes.

I still contemplate anger management when I think about it. However, I learned one of the most valuable lessons I have ever learned in my life regarding professional theatre.

It's just a show and my life comes first. Period.

There are a couple of things to consider. Firstly, everything in life is negotiable and theatre is no different. You can't work things out if you don't ask and while your manager or agent should be handling your priorities on your behalf, it is your responsibility to take care of what matters to most to you—even if it means turning down a job. Secondly, don't forget the things that really matter to you and keep them in perspective when your theatre life is speeding ahead full throttle. Shows will come and go, but you get to pursue your theatrical dreams on your own terms.

If you want to take a year off to start an orphanage in a third world country, then do it. If you need six months away from auditioning to plan your wedding, do it. If you are feeling anything but joy when

you walk into the room, then take a break and figure out what you really should be focusing on to bring your life into balance. One of the things I consistently find the most important for actors to solve is their living situation and financial circumstance.

If you are living on some party animal's couch and can't get a good nights sleep, spend time finding a better place to live. If you can't afford a place to live that feels safe and sacred, take time to find a survival job that will afford you that basic human need and be flexible enough to accommodate your audition life. Anything in your life can be stabilized and balanced if you take it on.

But how do we ultimately get clear on what we really want in our lives? Better yet, how the heck do we start to figure out what is really important to us in our artistic life? Let's start with what you've already learned through hard experience.

AUDITION MIND TOOL: SHOULDA WOULDA COULDA

Oh, you've been here, right?

We usually start this conversation with, "If I could go back and start over" or "I would do things differently now." The interesting thing about regrets is that they are gargantuan opportunities in disguise because they get us clear on what we *do want* and what we *will do* going forward.

Do not dwell on the past. Don't be afraid to cherish your regrets as life experience that moves you forward in better alignment with who you are and what you want. Wisdom, with it's wonderfully messy price tag, is still something we all aspire to achieve, right?

If you really want to grow, sometimes all it really takes is a little effort to do so. Usually, that comes in the form of some dedicated energy to thinking about something new or getting clear about stuff that you already have filed away in that magnificent brain of yours.

For the next half minute or so (this exercise takes personally takes me less than ten seconds), I want you to mentally rattle off your top five regrets so far in your life. Nothing you can come up with is too big or too small.

Count them on the fingers of your least dominate hand and please make an effort not to attach any emotional energy to them. It's just information.

Now, counting on your dominate hand (most of you will be righties), match each "regret" finger to an opposite finger that represents an "epiphany moment" that will serve you and your life going forward. I'm right handed, so my example would be:

LEFT THUMB: Didn't complete last two merit badges to make Eagle Scout. RIGHT THUMB: Will always go the last mile, no matter what it takes, to complete the things I start.

LEFT INDEX FINGER: Graduated early from college so I could start working sooner. RIGHT INDEX FINGER: Will never give up life experiences that are limited in nature to certain time frames of my life and cannot be reclaimed.

LEFT MIDDLE FINGER: Missed my best friend's wedding for a show. RIGHT MIDDLE FINGER: Never, never, never again will I sacrifice something so important to the people I love for a gig. I'll joyfully pass on a job going forward.

LEFT RING FINGER: I didn't know that someone I cared about very much, with a history of health challenges, would be leaving the planet

sooner than I expected. RIGHT RING FINGER: I call loved ones, make the effort to keep in touch and fly anywhere regardless of time/budget constraints to spend quality time with them.

LEFT PINKY FINGER: I didn't start my own company and set myself up for financial freedom much sooner in life. RIGHT PINKY FINGER: I'm committed to becoming a millionaire by creating great experiences for others and myself in theatre through great story telling, wellness and the pursuit of pure joy.

Now rub both hands together, quickly, until they're hot from friction. As you savor that warmth, feel how those life experiences mix together as great learning tools that will lead you to focus on choices going forward that bring you more joy.

If you have to remind yourself every so often when something comes up and you are uncertain, just look at your hands and remember you get to choose. Choose happiness in your life and the minutia of details will work out just the way it shoulda-woulda-coulda!

Rest your brain, my friend.

It's all going to work out the way it's going to work out.

"If there's ever a tomorrow when we're not together, there's something you should remember: You're braver than you believe, stronger than you seem, and smarter than you think. But the most important thing is, even if we're apart, I'll always be with you." — Christopher Robin (Pooh's Great Adventure)

THE ONES WHO JOURNEYED BEFORE US

As artists, I think we must constantly feed our minds and souls to keep our creative wells full. Have you ever stopped to realize that we, as artists, can renew ourselves through the legacy of other artists' work? How many millions of people have been healed by the music of Bach, Beethoven and Mozart? How many millions of people have found peace through the teachings of the Bible, Talmud or Bhagavad Gita? How many millions of people have read about some teenage shuckster and his best friend traveling down the Mississippi River because of Mark Twain?

The list goes on and on and while you may not have the desire to paint the roof of some church for most of your adult life (or supervise the project), you may forever alter some sixteen year old sitting in the audience enjoying your brilliant performance in *'Night Mother* and they will go on to leave an artistic imprint on millions of people because of those two hours.

That's the truth.

That's the beauty of art and don't let anyone tell you any different. That's how we can offer huge, constant creative outpourings to many thousands of kindred spirits (audiences and the like) and stay away from the cuckoo farm. It's all creative energy that can find and frame

your artistic life if you are open to receiving that legacy. Did you ever consider how important that is to the big picture? We matter.

Our flow as artists choosing moments in theatre allows audiences an opportunity to experience journeys they might not otherwise. If that isn't one of our most important obligations to our world, I can't imagine what else there could be. When we reinvest in our own myths and they flow into the experience of others. We create a community through entertainment that provides space and escape.

Flow. Mysteries. Life.

We are the storytellers and our job is very important no matter at what level and where we take it on...

AUDITION MIND TOOL:
A POET MOMENT

I find myself in awe of the beautiful poetry of Mowlana Jalaluddin Rumi, a 13th-century poet of the Seljuk Empire. He was a Sufi mystic and his poetic appreciation of life's divine fabric have now been made very accessible to our culture by various translators, making him one of the most widely read poets in the world.

Rumi's ghazals, or odes, look at how worldly presences flow together. I think that somewhere in any universal idea of flow we can find freedom. Call it personal freedom, artistic freedom, financial freedom, freedom to love who you love, freedom to say what you need to say, or even freedom to share your gifts without censorship from yourself of others.

AUDITION FREEDOM

Excerpt from Ghazal number 1393, Mowlana Jalaluddin Rumi
From Rumi: Fountain of Fire
by Nader Khalili

i was dead
i came alive
i was tears
i became laughter

all because of love
when it arrived
my temporal life
from then on
changed to eternal

love said to me
you are not
crazy enough
you don't
fit in this house

i went and
became crazy
crazy enough
to be in chains

love said
you are not
intoxicated enough
you don't
fit the group

i went and
got drunk
drunk enough
to overflow

love said
you are still
too clever
filled with
imagination and skepticism

i went and
became gullible
and in fright
pulled away
from it all

love said
you are a candle
attracting everyone
gathering everyone
around you

i am no more
a candle spreading light
i gather no more crowds
and like smoke
i am all scattered now

love said
you are a teacher
you are a head
and for everyone
you are a leader

154

AUDITION FREEDOM

i am no more
not a teacher
not a leader
just a servant
to your wishes

love said
you already have
your own wings
i will not give you
more feathers

and then my heart
pulled itself apart
and filled to the brim
with a new light
overflowed with fresh life

now when the heavens
are thankful that
because of love
i have become
the giver of light

*"Determine that the thing can and shall
be done, and then we shall find the way."
— Abraham Lincoln*

THE MAKE-IT-HAPPEN CLUB

There is no membership fee, but it is a very, very exclusive membership. Why? Because most people on the planet don't keep their word or do what it takes to create the life they want. Sorry, if you were expecting some idea of luck. Fuck luck. Life balance and personal happiness have nothing to do with luck.

They are about committed action.

You can take committed action with your thoughts, your words, your feelings, your emotions, your work, your play and your life. Want to be miserable and get no where? Blame something. Wallow in your self pity and history and see how far it gets you. If you want to suddenly find yourself somewhere even better than you ever dreamed, start dreaming and start moving.

I have a fabulously talented gal who found me and my workshops. I'd call her a student, but like many, she has become my friend. I'll never forget when she walked into the room to audition for my Broadway casting workshop. She's a really interesting type, she sang her pants off, she was borderline frenetic and in the end nothing but a bundle of smiles. There were many, many, many others who were more polished than she was trying to get a slot in this workshop. She walked out of the room and my dear friend, Carl, was at the piano grinning. Now, you must understand that Carl has been playing my musical workshops since I started them. He knows what I'm thinking without me saying a word. He said, "She's your new pet project,

right?". "Yup", I said without even going further. I liked her. I liked her a lot. I knew she would do the work. Boy, did she ever.

That gal busted her butt every week to learn, grow and spread nothing but authentic kindness to her peers. Shortly after the workshop, she decided to rally the troops to put on a showcase in New York City. I attended one of the rehearsals as a courtesy to the group and could see the writing on the wall watching way too many cooks in the kitchen. After spending hours and hours handling all of the details and trying to wrangle some synergy into this group, she watched the whole thing fall through. I know she was very disappointed. She dropped me an e-mail to ask my advice about possibly doing the show on her own.

I told her there was no other option.

No matter what the turnout or response, she would be creating her own opportunity to do what she loved and if one person got there to see it, she would be glad she did it. It turned out to be a huge success and a theatre venue invited her to extend. Not even a month after that, she landed the lead in an original new musical for the New York Musical Theatre Festival. Of all the shows (over 150) that were presented with everyone from unknowns to Tony winners, this feisty little ball of make-it-happen attitude won Best Actress for the festival. I have no doubt in my mind that if this particular project moves forward to a commercial venue, I'll get to add another Tony Award winner to my list of friends. And if not in that project, another one will find her or she will find it—that's how the universal law of attraction works.

Guess what the by-product is from this way of thinking? You'll suddenly find yourself doing it in every part of your life from finally reading that copy of *One Hundred Years of Solitude* sitting on your bookshelf to getting your PADI scuba certification so that the next time you're in Maui you can share some dunk time with the sea turtles.

AUDITION MIND TOOL: THINK BIG. DREAM BIG. FEEL BIG.

Do you think big? Think bigger. Better yet, *feel bigger.* Dream so big the guy next to you on the subway platform starts to dream big, too!

Pick one of your lifetime dreams. It can be any area of your life, but take a brief moment to make it ten times bigger than what it was when you first brought it to mind. Let it include more of everything—joy, happiness, love, money, fame, peace, whatever. Now really notice how it feels. Make it come to life emotionally in a way that you get sensory signals from your head to your toes. You're an actor! You do this all the time in your story telling and character work.

Apply all that stuff to your big-feely-dream.

If you dream of owning a house on the beach, then taste the salt of the ocean outside your bedroom window when you open the curtains in the morning. If you dream of jumping out of a plane, then feel your cheeks flapping next to your ears as you laugh wildly, heading toward earth. If you dream of being a huge Broadway star, then enjoy the feeling of greeting all your fans outside of the stage door and signing those playbills with a sharpie marker.

Think about your dream for a minute and just feel good. Whenever you find yourself with a spare moment, keep feeling your dreams, desires and awesome "think bigs".

They will show up faster than you ever imagined just by aligning great thoughts and feelings towards them. As your life unfolds more in tune with those good feelings about stuff, you will find that your theatrical life as an artist unfolds in tune with them, too.

"As your faith is strengthened you will find that there is no longer the need to have a sense of control, that things will flow as they will, and that you will flow with them, to your great delight and benefit."
— *Emmanuel Teney*

DON'T HOLD ON TOO TIGHT

Just this week I had a brilliant actress (we'll call her Farah) in my advanced audition workshop who was feeling totally stuck. I was surprised to say the least—she's was taking action, had just had a near miss for a huge role in *Wicked*, consistently taking class, in a great relationship, involved in her spiritual community—you name it. Quite frankly, she's the epitome of wellness compared to the majority of the talent pool. I was also pitching her for every project that anyone was putting out casting queries to me and my inner industry posse.

I told her to sit tight and trust that even though she couldn't feel movement, she was indeed far from stuck and things were just shifting and aligning for her.

Less than one week later (she sent me a text message today), she booked a show in New York, was offered an out-of-the-blue referral and appointment with one of the top commercial agents in town and went to a call for a hot new B'way show where the head of the casting agency herself mentioned how much her office loves her work and her picture and holds it up for everyone in the office to see an example of a perfect headshot everytime Farah is submitted for a project. Her actorly "chatter" was getting in the way of all the things that deserve relished celebration.

You just can't hold on so tight to everything that you don't allow for things to surprise you or it will make you crazy. Committed, clear action will always lead you closer to your intentions and desires. I'm a big fan of personal coaching if you need to keep on track or generate results in certain areas of your life. Do what it takes to enjoy everything you have right now and enjoy getting to all the things you intend to create in the future. Show biz is a tough nut if you hold rigid expectations of how it should shake down and who should get what. Particularly if you put your wellness in the hands of others.

You are the sole proprietor of your life.

You choose to swim in the show biz arena, you choose where to put your energy and you are totally-one-hundred-percent responsible for your wellness whether you are swimming upstream, floating, watching sea turtles or choosing to tie a brick to your left foof and sink to the ocean floor for a permanent time out.

Imagine the whole thing like a warm morning walk along the beach and watching the ocean waves roll upon the shore. Each pass brings some treasure and washes away the prints of those who came before you. On it goes and nothing much changes. You only get the smell of the salty air today because your prints will be washed away before you know it. Some days will be blustery and other may burn bright hot, but the waves will ebb and flow with or without your approval.

Enjoy them.

Show biz can be tons of fun or tons of hurt depending on how you approach it and no one on the planet will really care whether you play in the water or run far from the beach to find happiness. Did you really think they would? Better yet, do you think it's any different for anyone else in any other profession? Some days will be full of activity that we want and other days might seem like we're frozen in glacier #6 from the left in the Antartica of our professional career.

AUDITION FREEDOM

Our entire planet is struggling to survive itself and the next chapter in our evolution. Some cranky, self-important artist who blames the world for their lack of happiness and prosperity is so, well—cliché. I've worked with young hopefuls full of self entitlement and I've worked with mega-stars who appreciate every little morsel of artistry that finds it's way to them. I'll take the latter whenever possible because they make me a better person and we share our artistic endeavors around a sense of appreciation. Nothing ever stops moving! You might get caught up in the goo, but you can always ride it out. Swim a little, test the water and know you can always retreat to other climates at any time you decide to and for as long as you care to go. That is the ebb and flow of show biz and it will never change.

*"Embrace nothing: If you meet the
Buddha, kill the Buddha. If you meet your
father, kill your father. Only live your life as
it is, not bound to anything." — Buddha*

IF YOU MEET THE BUDDHA AT THE AUDITION — KILL HIM

Don't believe a word of this book.

You probably didn't expect that response so far into my irreverent wellness guide, but I want to totally deliver on the irreverent part.

Don't believe anything that anyone tells you unless it resonates in your reality with personal truth. You know those moments when you get information and something sits nice in your middle like hot soup and warm bread on a sleepy winter day. That's the resonate part. It's all perception anyway and the relevance to you is yours to make. I totally support information gathering. How else can we find comfort with our choices as we learn, try, fail, try and learn some more. Find the best coaches, mentors and get continued feedback, but remember everyone is trying to do the best they can to figure out their own lives as well.

I always get a little worried when people tell me about rules and my have-to-do's because my life should be mine to create, including the rules and the have-to-do's. In that little crunch of decision in every second of every day, I get to choose how I'm going to proceed with the information at hand. Get the information, but eliminate the rest of the emotional stuff around it if it comes at you with black and white borders.

AUDITION FREEDOM

They don't exist. Particularly in theatre.

There is a lot of invention and reinvention in what we do—both personally and professionally. Live it and love it. Laugh at it! What we think, we become. Think about what makes you feel good. Think about what feeds you artistically. Think about what will bring a smile to your face and a contribution to the world.

Too many actors don't think. They just do, do, do.

Doing is great in life if there is some thought behind it, but doing can be a direct reaction to thinking that others have the answer. No one has your answers except you. Sorry, but there is no short cut here. Take action with purpose and you will find you will have less and less *mindless reaction*. It's deadly to you in every arena, especially in your theatrical endeavors. I'm not talking about the work you do in rehearsal or on the stage, I'm talking about the work you do to have a healthy life while pursuing your theatrical dreams.

You have to do the work. Forever and ever and over and over.

No one will do it for you. No one can just tell you about it. No one can get you from A to Z without you handling your life. The novel thing about the whole idea is that you get to seek it all out yourself—so it can be *really* fun if you actually keep your eyes open for the ride.

"For every beauty there is an eye somewhere to see it. For every truth there is an ear somewhere to hear it. For every love there is a heart somewhere to receive it." — Ivan Panin

FINDING YOUR TRUTH

What is your truth? The question of a lifetime. The big kana—all wrapped up in your genetic code, life experience and creative dreams waiting to be found. Let me help you out a bit...

You'll be searching for it forever. Why? It changes! It's expansion of the mind and soul that defies any measly grasp on your part to figure out. The minute you figure something out for yourself, you'll be introduced to some new piece of information (person, life experience, world event, etc.) that will keep you guessing so that what you knew before is no longer enough.

Isn't that the whole point of being an actor in the first place? You love taking on the journey of creating new characters, telling super cool stories and playing around with others who find joy in doing the same. Good! There's a little bit of truth in everything you choose and it's your truth.

No one elses truth. Your truth.

Likewise, don't be taking on anyone else's truth as your own. Won't work. Period. If you want to find yourself as an artist, keep creating. Keep moving towards whatever visionquest you decide is yours and leave everyone else out of it. They can be your pom-pom squad on the sidelines, for sure. I love my inner posse for all the faith they bring to my life game. You'll need them when you drop the ball and need

someone to get you back into the game before the clock runs out. They're also good for half-time entertainment when you need a break so be sure to do the same for them.

Your work is your life. Your life is your work. So on and so on.

Want to find truth in your work? Play.

Play in the audition room. Play in rehearsal. Play with all of your life experience and be sure to create reminders in your daily routine to play so that when you find yourself doing things that feel out of sync with the life you want to create, you can come back and find ways to play even more. That's my definition for what is work when it comes to being an actor.

When you stop playing and creating, you're dead in the water. Time for something else to challenge you, stimulate you and refocus you towards finding your artistic truth.

What is your artist truth right now? What do you want it to be? What are you willing to do each and every day to find it?

That's the good question.

"Follow your bliss." — *Joseph Campbell*

NO ONE REALLY CARES ABOUT YOUR HAPPY-NESS EXCEPT YOU

You have many jobs in this lifetime, but the one that you have to do that no one else can do is taking charge of your happiness. You're the only one who really cares about it in the end. That's good! Don't hold other people responsible for how you feel in your artistic endeavors and be sure to surround yourself with people of the same ilk. I really don't think you can even hold your friends, family and loved ones responsible for your happiness, either. It's not their job to take on for you.

You might have many people who want you to be happy (and I wish that for everyone), but that little detail of your life is yours to create and own with pride or throw away at your leisure. It certainly is yours to create in your artistic endeavors. If doing shows doesn't make you feel like your on top of the world, then how could you ever expect to find good feelings in the audition room? The creative team can sniff it a mile away!

I'm not sugar coating the fact that the casting circumstance has it's pros and cons, but I've watched actors blame everything in their life that wasn't working on show business. There are a gazillion things to do in the world and a thousand different things you could do in theatre besides acting to be throwing around any misguided theories on cause and effect.

It's kind of rude, too. Who are you to be thinking that anyone should be responsible for processing all the information in their professional lives and worry about yours at the same time? I see it all the time.

AUDITION FREEDOM

There is so much going on in the audition room that has nothing to do with you when you walk out the door, that you'd be hard pressed to find stuff to support your feelings either way.

Choose to feel good.

Better yet, choose to feel *great* from the work you're doing and the actions you're taking to pursue what you love. Leave the other people out of it so they can do the same thing in whatever capacity they hold in your theatrical equation. Agent, casting director, director, colleague—they all have agendas that are not part of your happiness quotient.

Remember, you choose all your feelings about *everything*. Some experiences in the audition room will lend themselves more easily to your feeling good than others, but they are all a part of the choice.

Your choice.

"I would rather entertain and hope that people learned something than educate people and hope they were entertained."
— Walt Disney

MAGIC MOUNTAIN OR THE HAUNTED MANSION?

I've taken some flack over the years for my approach to choosing work, but since I'm a big proponent of creating the life I want, I'm sticking to my guns on this one.

You don't have to take every job.

Some people love roller coasters, some people love scary thrill rides. Some people hate theme parks and some people love barfing up two greasy elephant ears covered with cherry pie filling and powdered sugar after riding *The Cyclone*. It's all good.

I've heard many people say that working actors get more work. That's true on one level because you are creating relationships that ultimately get you more work. On that, I totally agree. I also believe that you have every right to avoid or pass on work that doesn't serve your career or your artist self or your happiness.

I don't care if you are fresh out of college and don't even have an Equity Card, you don't have to take every job. Your agent may tell you otherwise. Those "rule books" may indicate something else, but I think that everyone has the right to do the kind of work they enjoy.

So be it.

You may have less activity or a more winding path to your goals, but who the heck is responsible for your choices? You. Refer back

to the preface that talked about how there are no rules if you need some reinforcement. If you wake up feeling jazzed about the idea of auditioning for Pirate #2 in the national touring company of *Peter Pan,* hooray! Go! Grow your beard, buy some good luggage and travel the country. If the thought of doing *Steel Magnolias* in Detroit makes your skin crawl because you have a Great Dane named Spot and can't take him with you—stick to the ground with your survival job and be content with your choice to hang out until the right opportunity comes along. Please, please, please don't audition for the show in the first place. Nothing makes casting directors and creative teams more bonkers than to spend time on actors in the audition process who haven't really considered whether or not they would accept the job in the first place if it is offered. If you show up to audition, you better be ready to say yes to the offer if it comes along!

Big opportunities are usually clear-cut and don't require too much decision angst because your head and heart are telling you the same thing. However, I think when it comes to actually working and choosing auditions for projects that you really want to do, it comes down to the 80/20 rule. After all is said and done, you'll do 80% of your jobs because they're a paycheck and 20% of your jobs because they're artistically fulfilling. Usually, the 20% is the portion that you will bend over backwards to make work, even if there is no pay because it feeds your artist self. Those are my favorite things to do because of the new stories, character development, people involved, etc. I personally would rather spend a year doing all the things I do to handle my living expenses so I can do one of those totally juicy theatrical experiences. I have many, many brilliantly talented friends who just love being in shows all the time, no matter how they are cast. Singing spatulas, flying monkeys, skating jellyfiish, naked roustabouts—they love it all and I love them for it.

It really makes the theatrical world go round because our communities are actually quite small across the country and we provide the contrast in tastes that ultimately provide variety to audiences everywhere.

Spend some time considering those theatrical experiences that you love and those you don't. It will become an integral part of your audition freedom because you will actively pursue, prepare and enjoy the auditions that are aligned with your creative spirit. Do you get it?

You might be brilliant for a project, but if you are subconsciously dreading every moment of what the job will be like, then don't you think the creative team can sense that? We can! More so, you will ultimately not be serving the project because all that inner frustration will start to bubble up in rehearsal and the subsequent run. I always notice this stuff in technical rehearsals or previews because that is where actors really get tested on their attitude when they are fatigued and emotionally challenged. Get one unhappy actor in a fragile ensemble and the infection can be really dangerous. On the contrary, get a group of fantastically grounded people who really support each other and are thrilled to be there and the ship could be sinking (literally in *Titanic*) and everyone is smiling because they trust the glitches will all get worked out. Those are the people I work hard to get cast in everything because they can be trusted. There is no resentment whether it's a huge production contract or they are getting paid five bucks a day for the subway ride. Those moments are theatrical gold.

"Never be bullied into silence. Never allow yourself to be made a victim. Accept no ones definition of your life, but define yourself." — Harvey Fierstein

LISTEN TO YOUR HEART

If you listen to your brain all the time, you will make many mistakes. Mistakes (I use that term loosely since it can be quite subjective) can be super stepping stones to finding audition freedom, but over time they can take their toll on your wellness. If you listen to your heart, you'll find audition freedom around every corner.

You'll book more work, have more fulfilling experiences, make more friends and live a robust theatrical life. It's sounds a little touchey-feeley and might be a challenge when you're on your tenth call-back for the new Terrence McNally play on Broadway that you really think might be your Tony ticket, but you still have to do it.

Listen to your heart because that is the one true voice that will speak from a place of clarity. It will take care of you and put your wellness first. It will also align everything in your life to be in sync with what many call the "greatest good". I know this to be very true. You know the phrase, "When one door closes, another one opens?"

It's bullshit.

It's more like, "When one door closes, a thousand more open." That's closer to the truth, whatever truth is. We are constantly creating experiences and you already know something very valuable to your audition freedom based on experience. You already know that whenever you do not listen to your heart (or gut if you like that physiological analogy better), things can go awry. They don't feel as

good in the long run. They probably don't feel as good in the short run, either. Turn off your iPod and Nintendo Wii once and a while and listen to your heart in stillness so you can stay in tune to your own personal GPS guidance system.

If you listen to that intuitive inner voice, you will find extraordinary freedom in every aspect of your daily life, including auditions. Isn't that what inspiration really is? It's some version of creative instinct where ideas magically pop into our head (like a wellness book for auditioning) and suddenly you find an extra ticket in your pocket for another ride at the carnival. The cotton candy is free simply because you're here.

You get to taste it all!

PART SIX

HAVE FUN.
NO, REALLY.

VP BOYLE

"I will not die an unlived life. I will not live in fear of falling or catching fire. I choose to inhabit my days, to allow my living to open me, to make me less afraid, more accessible, to loosen my heart until it becomes a wing, a torch, a promise. I choose to risk my significance; to live so that which comes to me as seed goes to the next as blossom and that which comes to me as blossom, goes on as fruit." — Dawna Markova

UNCOMMON GROUND

I waited to write this chapter for the a moment of inspiration that would fall into my lap and be the perfect example of what I'm trying to convey. It happened out of the blue in a Starbuck's in Chicago while on vacation. I walked into the hopping-java-joint-from-hell on the corner of Belmont and Clark to approach the counter. The barista, we'll call him Taylor for kicks, had his back to me and was singing at the top of his lungs his own little anthem:

WHAT YOU WANT? BABY, I GOT IT.
WHAT YOU NEED? YOU KNOW I GOT IT.
YEAH, HA! OOOOOAAAAAHHH—OOOOOHHH.

It was totally on par with the scene in *Pretty Woman* where Julia Roberts is in the bubblebath the size of a pool with headphones singing as if it were heaven. It was heaven for her, wasn't it?

So, Taylor The Latte Boy turned around and asks me what I'd like in between lyrics and a huge smile. Now I was the one in heaven to be participating in this little vignette. One of his coworkers suddenly

scolded him for singing because he didn't sing well enough for her liking. I then scolded her for scolding him since he was having a blast, doing his job and spreading his infectious joy to caffeine deprived yuppies in Lakeview. She backed off and he thanked me.

And he kept singing by the way...

That's what our work should feel like, whether it's on the stage, in a classroom, or during some audition. It's the outside world or our ego that starts to dictate some fucked up idea of good and not good enough. Who cares if it takes you longer to get your skill set to the level of Broadway shows or Shakespeare in the Park? Keep going. If you're willing to the work, it will eventually come to pass.

I have a gal in my workshops that I adore. She came to me with a great, intuitive acting style and modern dance background. She's so naturally funny, in fact, that I've been encouraging her to pursue sitcoms—she's that good. Her voice was youngish and because all of her training was devoted to other things, that needed some catching up. I told her the truth (which I always do) that she would have to really commit to vocal training for the next year or two, but that I thought she would progress fairly quickly to a level that would serve the musical theatre world at a professional level. Do you know what her comment was?

"I don't care if I'm as old as Judi Dench before I get my Broadway debut, *I'm going to do a Broadway show*".

Wow! That is powerful. And so she shall. With that awesome attitude towards doing the work and knowing what she wants, she can't fail. I guarantee you that I will be at that debut performance no matter what I have to rearrange in my schedule to be cheering her on!

This is just one of the numerous inspirations I get that fuel my approach to the craft, our theatrical community and the great things

we create. If you find yourself in one of those moods—you know the ones that are the foundation for eating a whole cheesecake and watching *Beaches*—find something that takes you to the silly place and away from the fork and remote control. It's hard not to have fun when you're acting like a child. Children are very well suited to impossible tasks because they don't give any energy to limits. Find ways to get back there every day. You probably know them already but choose to forget sometimes just so you can wallow.

Fine. Wallow for one day. Eat the whole pint of Chubby Hubby Ice Cream if you have to and then starting playing again.

Have fun! If think you have forgotten how to have fun, sing at the top of your lungs in Starbuck's and see if you can find your sweet spot in life again. The fun, outrageous place will yank you right back. If you land in jail, sing really loud there and tell the judge to buy my book.

"It is your work in life that is the ultimate seduction." — *Pablo Picasso*

SILLY PUTTY

I'm really dating myself here, but I used to love Silly Putty, this awesome taffy-like rubber material that came in a plastic egg. Who in the world would ever think that it would make a great toy? I loved it. You could press it against newspapers and lift off images before stretching them into all sorts of crazy shapes. It really was the first stress reliever on the market!

Over time, it would get all sorts of character embedded in it like dirt, dog hair, part of the Marathon Bar[15] that melted in your other hand, etc. The reason I bring it up is that to really find freedom in the audition room, you have to be flexible. I'm not talking about taking adjustments from the creative team, although that is another form of flexibility. I'm talking about a natural openness that comes with having no pre-conceived images of how things should go.

You can't know how things are going to go. You can have an idea based on history of how things might show up, but there are no rules. It goes like it goes like it goes—and it is never quite the same, really. Thank the theatre gods. It would all end up so dreary, if that were true.

If you hold on too tight to some preconceived notion of how things should go, you will never find true audition freedom. How could you? The very audition itself is a moving entity of conscious creation.

Chew on that for a while.

15 Now I've really dated myself in Generation X history.

AUDITION FREEDOM

Many, many people are participating in the experience of any single audition process which may last for hours or years depending on the life of the project.

You can participate in that creative process, but you can't control it. You might be responsible for your work, but you can't dictate the final outcome. If that were the case, more people would be playing the lottery.

"There are some occasions when a man must tell half his secret, in order to conceal the rest." — Lord Chesterfield

KEEP POP ROCKS IN YOUR MOUTH

Wanna take every single audition you ever do to the next level in one easy step? Keep a secret.

Something delicious that you can hint at, tease us with and ultimately never reveal. Rest assured, you should be revealing something, if not a lot, but not *everything*. That's where depletion comes from and quite frankly, it's really boring.

Haven't you ever been around someone who tells you absolutely every detail of their life, never really taking a moment to let you participate or share as well? We've all been there. Snooze-ville.

However, don't the people you come across who ride the interactive wave of relationship and conversation (while gently revealing something new when the time is appropriate) leave you wanting to know more?

It's definitely a talent that some people have naturally. Others have to work at it, but it can really serve you well in your audition life. If you've ever tasted Pop Rocks Candy you can't help but find yourself with a mischievous grin every time they start jumping around in your mouth and releasing mini explosions of tasty sugar and 600 PSI Carbon Dioxide for some silly pleasure. No one can see them in your mouth, but that wackadoodle experience is yours and is real on the inside. I think the same thing is true in your story telling and character work. Keep a secret that you can play with either as an activity or way to resist giving something away. It brings up a host of tactics (useful

actor puke language) that become valuable as a tool in a room full of fluorescent lighting, no clear props, no stage and with a bunch of random strangers looking at you.

Keep a secret. I dare you. Then watch as your audition life suddenly starts to sparkle with a magical sense of excitement and effervescence.

AUDITION MIND TOOL: KEEP SOMETHING FOR YOURSELF

I'm going to help you create your own talisman. A talisman is an object that is carried for protection and that has been charged for that purpose. It can be any small object that one may carry.

Find any ordinary object that is in your possession or nearby *right now.*

A ring, a rock, a paperclip, a penny. Anything will do, but you have to do it *right at this moment.* Hold it in your right hand and imagine that it is covered in a cool flame of white bluish light that purifies it of any past energy. Ask that all negative energy be cast back to the universe to be transformed into love and light. Now, move the object to your left hand and hold it next to you heart.

Infuse it with one clear idea: *I choose to play. This is my talisman which will help keep me safe and to find never ending freedom in my auditions. I infuse it with protective energy from every corner of the universe. It is mine to keep for as long as I choose to keep it. I do not require it to be joyful in my audition life and it its usefulness is only to remind me that I choose to play. It is my secret to keep or to share. So be it.*

Now tuck it away in your pocket and bring it to your next audition.

"I always knew I was a star. And now, the rest of the world seems to agree with me." — Freddie Mercury

KALEIDESCOPES, DIET COKE & QUEEN'S GREATEST HITS

I think every audition deserves some consistent personal ritual—and standing in line for hours in the cold to get an appointment card doesn't count. While that may be necessary at the first open call for a Broadway hit, it is not my idea of personal treats.

I have found it particularly useful to encourage post-audition rituals so that your brain jury doesn't drag you kicking and screaming into the vortex of darkness like Freddy Krueger pulling Johnny Depp down inside the bed to kill him. Yes, it was Johnny Depp—I'm old enough to remember.

What is your post-audition tradition? Do you have someone you hang out with and chat? Something you love to do that brings you back to your normal "at peace" baseline?

I always plan an immediate movie date with a tub of buttered popcorn and a Diet Coke the size of my head. I love it! Usually I head over to the theatres on 42nd Street since they are so over-the-top in a Big Apple meets Vegas kinda way. I also limit my post-audition movie treat to animation, cheesy comedies, summer blockbusters and films that champion the human spirit. Nothing hard to take or that requires me to translate foreign subtitles. I want to chill and create space from the artistic work I just did so that when I leave, I'm rested and have some objectivity on the experience. It's called taking care of yourself and no one will do it for you except the person you look at in the

mirror every morning. It's amazing how well it works and let me tell you that I really feel it when I don't reward and acknowledge my artist self with ritual.

Our gifts are shared so often that renewal and rest are requirements to survive. If you aren't in total alignment with this, look back the to last audition experiences you have had where you didn't give yourself time to rest. You probably felt out of sorts for the rest of the day, edgy and irritable or stuck in a frustrating stream of consciousness firing through every synaptic connection in your brain. There's only so much Seratonin your body can produce in a certain period of time so don't waste it!

I think there is value in creating your post-audition ritual as something you do by yourself, but if you have to do it with other folks who may or may not be actors, be sure to set limits on the discussion topics. If you absolutely must have fifteen minutes to rehash every detail of how you think it went and what they thought, set a timer and then move on with your day. Incessant discussion about your auditions will never serve you because you will never be accurate and will start to create theories about some fictional reality that you think must have existed, good or bad. Learn to let it go and set yourself up to do just that with your post-audition ritual.

AUDITION MIND TOOL: PLAN YOUR POST-AUDITION RITUAL

I think you might consider three or four elements to build your post-audition ritual, but I want to stress that anything that brings you authentic joy is fair game.

1. Music you love. For all you show queens out there applying this idea to musical theatre auditions (and I

love musical theatre), make sure you listen to something else for your ritual! You can have your music for getting energized before the audition and have music that keeps you in the sunny place afterwards, but keep them distinct and save them for their intended ritual use.

2. An edible treat! For me, this is popcorn. Anyone who has an eating disorder of any kind, I'm warning you to stay away from this if it is your slippery slope. I sometimes will enjoy a Mexican dinner because I love authentic Mexican and Tex-Mex food.

3. Brain drain, pure and simple. Do anything that gets you out of your head. Movies, a walk in the park, video games, a killer workout at the gym, sex with your lover—whatever will clear, well, whatever it is that you need cleared.

Take a moment to really get creative on a three-part experience of your choice to be your post-audition ritual at the next available opportunity. Find things that bring you joy, are easy to do and are very sensory. Touch, feel, hear, taste, smell, etc.

In less than one minute, you should have a three part action plan in place for your next audition. How does it look?

If you want to really make your post-audition ritual effective, be sure to never negotiate it away and learn to relish it. Try to block out at least an hour or two with those things you enjoy and allow for it in your schedule.

You deserve it.

"No one realizes how beautiful it is to travel until he comes home and rests his head on his old, familiar pillow."
— *Lin Yutang*

CREATING SACRED SPACE

Television makes me crazy. More specifically, the noise from a television really messes up my psyche because of content and distraction. The news drives me nuts because 99.9% of it is totally biased, sensationalistic and filled with human trauma. Regular cable, which might contain some kernels of good episodic entertainment, is filled with a slew of advertisements that tell me all the things about myself that I should fix or where I'm incomplete.

I *really* hate television.

It is probably why I enjoy going to movies so much because I can choose the content, enjoy an uninterrupted experience and chow down on some crunchy buttered goodness at the same time. I had roomies for the better part of my twenties and early thirties so every once and a while had to suck up the price tag of living with a TV junkie. Not good.

Some people love it and I totally respect that, but it doesn't keep me healthy and well. I end up not enjoying my living space and slowly morphing into Crankarella. Our homes are the foundation of our renewal! How can you deal with all the unknowns of your daily life if you don't feel comfortable and safe in the place where you lay your head, feed your soul *and just rest.* Creating sacred space (whatever that is for you) is very, very important to your creative wellness. If you are someone who enjoys the dorm-like social aspect of living with five people at any given moment and communal spirit, great!

Find an old house, have a revolving door of tenants and go with it. If you're someone like me, you might consider working your tail off to own or rent your own space near nature and with room to sprawl out anywhere in your home under your own terms. It's all good.

The point of creating sacred space is that it is for you to renew yourself, however that can be the most healthy.

Do you like to wake up, meditate on a mat in the center of the floor in a room with no furniture while burning frankincense? Good!

Do you wake up and find great peace watching *The Morning Show* with a cup of coffee so thick it could tar the street outside your door? Great!

If you are in a loving relationship and like to have morning sex on the kitchen table before making buttermilk pancakes for breakfast— excellent! I just don't want to hear what you do with the maple syrup.

Have fun creating a sacred space and find ways to fill your home with beautiful things that bring you joy. If you want to motivate some really awesome shifts in your career, clear your clutter.

It's true. Purge your living space of anything unused or unwanted such as papers, old clothes in your closet, tax returns from 1995 and the hundreds of extra headshots you never use from three photo sessions ago. Want to feel great the night before a big audition? Clean out a junk drawer.

You're next day will go great.

AUDITION MIND TOOL: CALL IN THE CLEAN-UP CREW

In virtual brain-land there are no budget limitations, so you can dream big. As always, dream in color!

Close your eyes for sixty seconds and mentally walk through your home from the front door to your bedroom, stopping along the way to visit any rooms or common areas that are a part of your daily routine. I want you to do nothing more in your mind than notice one thing that makes you feel good and one thing that makes you feel not-so-good.

Work fast! If you stop to really brew on things, you'll lose the momentum of this exercise. If you work fast, you'll make clear decisions that can serve you on creating sacred space. For example:

Entryway: I hate tripping over all my shoes. I should get a shoe rack. I love, love, love that the first thing I see as I walk in the door is my Mark Rothco print. It welcomes me home!

Kitchen: The vintage tea kettle always sitting on the stove makes me happy because it reminds me of my Grandma. Dirty dishes in the sink bother me a little and I really have to deal with those before bed because I like being able to choose any mug or bowl I want in the morning.

Get the idea? Notice, assess and keep mind-walking. When you get to the last room in your living space and have picked a few things, just open your eyes. I guarantee that by doing this exercise once or a hundred times, you will inadvertently start making adjustments in your living space to be much more sacred, spiritually sound and invite artistic healing into your time there. You will find more rest, more renewal and more creative soul food because it will be more indicative

of you on the inside. If you find challenges in certain areas (such as endless stacks of paper), start to solve it with creative solutions or systems that you put into action so that your space will start to maintain itself in the most sacred way. Hire a coach! Personal trainer, professional organizer, financial consultant, feng shui designer. I'm sure you have a roster full of coaches for everything from dialects to vocal production.

Get your home in order. It's really important so that when you are being an artist, you have a place to go that will wrap your artist self in a blanket of warmth.

Give yourself that very easy and special gift of creating sacred space!

"A bit of fragrance always clings to the hand that gives you roses."
— *Chinese Proverb*

YOUR NOSE PRESSED AGAINST THE GLASS

You will ultimately get most of your theatre opportunities through relationships. People that like you, that you've worked with, taken class with or auditioned for will be the ones that are throwing your name in the hat when someone is looking to cast a project. Interestingly, I've found that if you've slept with someone, it actually makes it much harder to get cast so the theatre community must work a bit differently than the film community. Imagine my evil grin right about now.

Getting to know people takes time. Networking and keeping busy will always speed things along and keep you in the swirl of it all, but don't forget to participate in the game. One of my favorite things in the entire world is recommending awesome, talented people for work. They are usually my friends, as well. Not a coincidence, really, since we are discussing relationships.

Imagine that you and all of your theatrical circle of relationships and friends are in this together. You are, just so you know. Use every opportunity to promote them and ask them to promote you, too. Sooner or later, someone is going to break through and everyone will move forward because you will all want to continue to be around each other, both in work and play.

Quite simply, if you really want to increase your theatrical outlets, *champion your friends*.

There's a couple of interesting lessons in this strategy. At first glance, the one that probably comes to mind is the goodwill aspect of it all. You're right! You'll feel great knowing that you are helping someone in a way that might not have been possible if you had not seized an opportunity to promote someone you adore. The other benefit (when you're the recipient of this type of unforeseen opportunity generated by your industry relationships) is that you get to *practice receiving*.

Artists suck at receiving.

We learn to give, give, give until we have forgotten how to receive, receive, receive and suddenly wonder why we feel completely burn out and depleted. You know where I witness this the most? Around money and relationships. I guarantee over half the people that will ever read this book will have major issues with those one or both of those things. That's where you can practice being the biggest giver and receiver!

Introduce great people to other great people. Put your name behind recommendations you trust. Go out of your way to get someone an opportunity if you know it's a win/win for everyone involved.

More importantly, ask for what you want from your industry relationships and personal relationships so that you can practice being a better receiver!

"Finish each day and be done with it.
You have done what you could. Some
blunders and absurdities have crept
in; forget them as soon as you can.
Tomorrow is a new day. You shall begin it
serenely and with too high a spirit to be
encumbered with your old nonsense."
— Ralph Waldo Emerson

WHEN YOU LAY YOUR HEAD DOWN

At the end of the day, when you're wrapping up another chapter in this zany journey that you're on, you really need to allow release with appreciation. It will add to your audition life and overall wellness in a way that is more measurable than any class you will ever take. Learn your lessons well! It's so easy to get distracted and suddenly find that days, months or years have swept by before you realize you should be grateful for them. Start now with little reminders. I actually have a little sign on my kitchen cupboard since I usually start and end my day there that says "I am grateful for..."

It's my gentle little reminder not to take for granted any of the crazy days that I get to add to my lifetime experience. Interestingly, it has a different slant in the morning than it does at the end of my day or evening and both of them serve a greater purpose. The morning reminder gets my brain in the hopeful place for what will show up. It's full of possibilities, dreams, wishes, energy and all around good will. It's really awesome when I've slept in without setting an alarm!

The evening version is appreciation and reflection on what transpired, whether it was enjoyable or not and what I might have learned. With less than ten minutes a day, I encourage you to put some mind time towards what is actually going down in your life.

Then let it go. Tomorrow is a clean slate, a fresh canvas and don't ever think differently about it. We need to clear the days events in a real way so we can move on and be present for the "what's next" as it catapults towards us.

Particularly in audition-land!

If you don't allow the audition experiences in your life to flow through you, they can make you crazy. We've all been there—and some days are easier than others—but find ways to move on so that you are truly available for each day that comes your way. Heck knows, each one can be found gems or lost treasures depending on on your approach.

AUDITION MIND TOOL: THE DAY IN REVIEW

At the end of the day, when you you've banged out one or more auditions and you're scrubbing off the daily dirt (literally and figuratively) and getting ready to dive into your bed for dream-land, consider this particular mind tool. It's easy, fast and very effective in clearing your mind for better rest and renewal.

Mentally visualize everything you did today. It's important (and much more effective) to really start from the time your eyes opened up in your bed to now. Talk to yourself if you have to do it in order to keep the linear time line accurate. House mates will think you're crazy and that's fine—you're just improvising some reality based memory work since you are, after all, *an actor.*

Can you remember what you ate for breakfast, how you chose your clothes, the dishes you left in the kitchen sink, the sides for *Law & Order* that you ran through for tomorrow, the call to your agent about getting seen for the replacement in *The Lion King*, etc. Include

everything from the burnt coffee you spilled all over your keyboard while checking e-mail to the glorious high C you floated without warming up at the audition for *My Fair Lady* when they asked you to sing soprano out of the blue—even though you've spent the last ten years of your professional career belting heinous alto parts. Don't forget to remember the crush you had on the musical supervisor because they were soooooooooo hot.

Now forget it. Let it dissipate into the air and leave you clear for a good night's sleep without all that chatter swimming around in your cerebral cortex.

One last thing to remember in this exercise...

Say thank you.

"Life is short. Eat dessert first."
— Jacques Torres

"I second that!" — VP Boyle

CUPCAKE KARMA & SMALL CELEBRATIONS

I find that actors forget one small part of the audition equation. Celebration!

Celebrating the awesome auditions and the stinky ones that will make for great war stories later and are half the fun of being an actor. Think about all the time you spend talking about "the biz" with your peer group and I will wager that over half of it is about auditions in some way shape or form. Learning to let them breathe as artist moments that feed, fuel, teach and taunt is the stuff of legend.

It funnels into the appreciation theme that I have woven throughout this entire book, but it bears repeating so you really grasp the care you have to give your inner artist in all it's child-like wonder. Look at your auditions as a reason to celebrate. The really great ones that land you work will always be a bit easier, to be sure. However, the ones that do not fall in that focused percentage require as much or more celebration so that your inner artist is continually interpreting the experience in a healthy way that leads to more healthy (and fun) experiences in the audition room.

I'm fond of celebrating my students, my family, my friends and myself and usually do it in a formal way. I eat cake. I'll make my way to my favorite bakery in New York[16] and eat a gloriously home-style cupcake amidst vintage decor. Other times, a fresh fruit margarita in the summer on the sidewalk cafe of a yummy Tex-Mex joint.

16 Billy's Bakery, 184 9th Avenue, NYC, 10011 • www.billysbakery.com

AUDITION FREEDOM

That's my celebration! I celebrate me and my journey and all my glory with chocolate frosting on my nose—sometimes it includes the glorious goofs. I'm always game to goof again! A hundred years from now, no one is going to remember the time I forgot my lyrics four times in a row with a room full of friends (producer, casting director, director and musical supervisor) asking me never, ever, *ever* to sing that particular song again.

Cupcake, anyone?

"Everybody can be great because anybody can serve. You don't have to have a college degree to make your subject and verb agree to serve. You only need a heart full of grace. A soul generated by love."
— *Martin Luther King, Jr.*

UNDER YOUR BIG ASS ROCK

Sabbaticals. Soul breaks. Vision quests. Retreats. Plan things that feed you. If you don't plan them, guard them and commit to them —they will never happen.

I love when show biz people ask me "Where have you been?" Rather than spew a barrage of credits or projects or travel itineraries, I simply say, "I just went under my rock for a while for a sabbatical."

You should see the range of responses. It's quite comical because there is an unfortunate trend amongst show biz professionals to spew. I don't mind hearing some of that, but sometimes I'm not interested in what friggin' show someone has done or what callback they just nailed. I'm more interested in the fact that they took a trip to Africa, their mother just had heart by-pass surgery and is doing well, or that they have a new love interest that they met after tripping up a flight of stairs outside their apartment. I'm funny that way. It is so easy for huge amounts of time to pass in the thick of trying to book theatre jobs, that if you don't just plan periods of time to do things away from the biz, they might never happen.

What are the things you put off or negotiate away because you think you might miss something? What are you missing? A show? An audition for a show? Come on! You're missing valuable parts of your life, really. Have you traveled this year to somewhere just to experience

it and not because of work? How about a surprise visit to a family member or friend in another part of the country? Do you ever take workshops, classes or training that do not have to do with theatre?

If you dream of hiking across Italy, set dates and book the flight—you can figure out the rest later. If you have always wanted to swim with dolphins in a natural habitat in Australia, hop on to the internet and just do it. If you want to teach theatre to orphans in India, make it so.

I find that talking about something I want to do makes it a reality because I'm held to my word. I can promise you that every time I tell a friend I'm going to do something, I end up doing it so I don't play the fool to my rants and raves.

I love sabbaticals, soul breaks, vision quests and retreats and encourage every person out there that has to navigate audition life to create them. You can. You will. And you'll find you're much more successful during your theatrical endeavors because you have these deliciously chosen experiences to ground you. Make them happen.

"Everything is out there waiting for you. All you have to do is walk up and declare yourself in. No need for permission. You just need courage to say, "Include me". Providing you have the energy to pull it off you can do what you like. And the Universal Law, being impartial, will be only too delighted to deliver." — Stuart Wilde

IT'S NEVER A COMPETITION

When it comes to theatre, there really is only one person in the race to artistic expression. You. While one could argue that many people are vying for a very limited amount of theatrical employment—which is true—the decisions and way that employment is allocated is very subjective in the final casting mix. It all becomes specific to the negotiation of a creative team based on many, many variables that have nothing to do with you. What I offer to you having lived on both sides of the table for so long in the Broadway community is that everyone in the final casting mix is quite capable and pretty awesome to hang out with on every level.

No one is competing against someone else. There is not an official scorecard rating finite measurements of theatrical assets. We are in the business of casting actors who share their humanity through artistic expression. The combination of many things adds up to a whole that is very complex and not something we can put our finger on all the time.

Look at the cast of *Friends*. On one hand, they are all the same. Age range, comic sensibility, attractiveness, urban appeal, etc. On the other hand, some are men and some are women. Did the men compete with each other for roles? Did the women?

AUDITION FREEDOM

I'm sure the writers and casting team were looking for some specific essences when they first wrote the show, but in the end one person walked into that room and it *all just felt right.* Once that first one was cast, the other roles started to make more sense with all the fabulous actors in the final mix and offers were made. Because the relationship of two totally talented and fabulous options is so important, it can sometimes come down to who will compliment the first casting commitment, making the who process a bit of a roll out. Someone terrific might be on the table (a casting term for someone in the final mix—literally a picture on the table) who ends up never getting the job because of how it all shakes down.

I hear the phrase, "I'm always up against Mr. So-And-So for a job". No your not. You're always "in the mix" with that person if you bring similar qualities to the creative team and share similar pockets of the biz, but sometimes having you will serve the project better and sometimes having Mr/Ms. So-And-So will serve the project better. Throw into the hat the fact that many successful plays and musicals will have more than one production running at the same time and you can bet your bamboozle that everyone will get to play somewhere sooner or later.

One reason I think actors really need to get out of their heads when it comes to any idea of competition is because it comes from an ego-ish place that will ultimately hurt you. It's the starting point or hiding place for many unseemly qualities like jealousy, fear, aggression, insecurity and so much more.

Chill out and do your work! Keep yourself focused on yourself, your artistry and your theatrical journey and not on some imaginary pissing contest with someone else.

We all have our place in the world of theatre. As you spend more and more time pursuing your craft, you may get a heightened sense of your marketability and can certainly use that information to dictate

your life choices, but I guarantee you that as soon as something starts to seem apparent, the industry will change or you will grow making any present theory null and void.

Can you see by now that when you raise your awareness on the idea that theatre is a part of your life, you create the opportunity to find artistic freedom in your *choice to do theatre*? Audition freedom is nothing more than true artistic integrity with some psychological wellness about the casting circumstance that allows us to do *more theatre*. This is true at any level, whether you are making your living as an actor or using it as a creative outlet in a non-professional arena.

Good for you! No, matter how you feel about auditioning right now as you read this, I can give you the same guarantee I give my students and it works: Live your life and make choices that feed your soul and everything will work out. Your happiness is never going to come from one show, one role or one little goal checked off your accomplishment list. Your happiness is going to come from having a life that you create and appreciating it along the way.

I hope that you discover that type of freedom sooner than later, but realize that we all have our roads to travel and you might find that inner truth as soon as you burst out of the womb or when you're decades older reading books with your great grandchildren. Who knows?

You will.

"A man travels the world in search of what he needs and returns home to find it." — *George Moore*

THE ROAD HOME

I think of a life in theatre (and I think about it a lot) as a garden patch along side the road home. We stop to get our hands dirty and create some pretty interesting life experiences. Left unattended, it can easily become overgrown with weeds or wither to a barren memory of what it was. There can be periods of magical blooms and delicious fruit when it is tended to with care. Even when it is kept pruned, plowed, watered and nurtured, there might still be a season of flooding or drought that claims a prized harvest. We can always plant new seeds by discovering new dreams, new people or new chapters in our theatrical scrapbook. It goes like it goes! We spend our lives figuring out, well—our lives. Take time to sit and drink lemonade with some stranger who seems to be a thousand years old and be sure to send them away with an armful of bounty from your theatrical garden. I invite you to enjoy the road home, noticing stuff, meeting people and trying to remember who you are and why you are here.

Keep learning. Keep dreaming. Keep working. Keep moving. Keep living your life and bring all that juicy experience into the audition room so we can play with you, learn from you and grow with you. In that possibility, freedom finds everyone—including you.

VP BOYLE

THE END

VP BOYLE

REMEMBER TO LIVE IN THE WONKY PLACE!

NEED A DOSE
OF IRREVERENT INSPIRATION
FOR YOUR SCHOOL,
COMMUNITY GROUP OR
CORPORATE EVENT?

VISIT
WWW.MAXTHEATRIX.COM
FOR UPCOMING EVENTS, NEW PRODUCTS
AND BOOKING INFORMATION
FOR VP BOYLE

COMING NEXT:

AUDITION JUICE
100 WAYS TO LOVE YOUR LIFE AS AN ACTOR

CPSIA information can be obtained at www.ICGtesting.com
Printed in the USA
LVOW08s1023140716

496314LV00002B/75/P